FASHION CITIES AFRICA

This publication was inspired by an exhibition of the same
name shown at Brighton Museum & Art Gallery, UK,
30 April 2016 – 8 January 2017.

FASHION CITIES AFRICA

EDITED BY HANNAH AZIEB POOL

intellect Bristol, UK / Chicago, USA

First published in the UK in 2016 by
Intellect, The Mill, Parnall Road, Fishponds, Bristol, BS16 3JG, UK

First published in the USA in 2016 by
The University of Chicago Press, 1427 E. 60th Street, Chicago, IL 60637, USA

Series: Street Style
Series ISSN: 2047-0568 (Print), 2047-0576 (Online)
Copy-editing: Emma Rhys
Layout Design and Typesetting: Emily Dann
Production Manager: Gabriel Solomons

Cover image: Kiongera Ndugire, shot in Nairobi by Sarah Marie Waiswa
Inside front cover image: Mystikal Ebony, shot in Johannesburg by Victor Dlamini
Inside back cover image: Louis Philippe de Gagoue, shot in Casablanca by Deborah Benzaquen
Back cover image: Nike Davies Okundaye, shot in Lagos by Lakin Ogunbanwo
Illustrations by Lulu Kitololo Studio

ISBN: 978-1-78320-611-7
ePDF: 978-1-78320-612-4

Printed & bound by Gwasg Gomer Cyf / Gomer Press Ltd, UK.

Fashion Cities Africa has been developed and published through a partnership between Royal
Pavilion & Museums, Brighton & Hove, and Intellect Ltd, with the support of the James Henry
Green Charitable Trust.

Authors' acknowledgements

The authors would like to thank all the interviewees, designers, stylists, bloggers, makers, creatives and models who took part in the book, and in particular those in Nairobi, Casablanca, Lagos and Johannesburg who welcomed us to their cities and helped us capture the fashion scenes. Hannah Azieb Pool would also like to thank Milisuthando Bongela; Ama Josephine Budge; Sunny Dolat; the team at Intellect Books; Carrie Kania at Conville and Walsh; Lucy Manning; Maria McCloy; Helen Mears and the team at Brighton Museum & Art Gallery (Royal Pavilion & Museums); and Mmabatho Selemela. Helen Jennings would also like to thank Lakin Ogunbanwo, Amine Bendriouich, Deborah Benzaquen, Kenza Diouri, Karim Kabbage and Enyinne Owunwanne.

Acknowledgements from the Fashion Cities Africa exhibition curators

As UK-based museum curators and researchers, we have been continually aware of the limits of our knowledge and, as with any exhibition, have sought out advice and input from specialists wherever possible. We are grateful then to Hannah Azieb Pool and Helen Jennings who have provided advice and guidance throughout, and to others who generously gave their time and shared their knowledge with us: Avis Charles, Edith Eyo, Julie Hudson, M. Angela Jansen, Tony Kalume, Lulu Kitololo, Sarah Naomi Lee, Jenni Lewin-Turner, Mary Frances Lukera, Thomas Onyimba, Mariam Rosser-Owen, Jacqueline Shaw, Tshepo Skwambane, Chris Spring, Nicola Stylianou, Lou Taylor, Carol Tulloch and Joma Wellings Longmore.

We are also grateful to our partners at the Sussex Africa Centre at the University of Sussex for their support throughout and for the joint funding of a dedicated doctoral award. Particular thanks go to JoAnn McGregor and Steph Newell. We also wish to thank our colleagues at Royal Pavilion & Museums, Brighton & Hove, for their ongoing support.

A huge thanks goes to all the designers, makers, stylists, bloggers and enthusiasts we have been privileged to meet during the process of working on this exhibition. Getting to visit the four cities and to meet some of the incredible creative people who work in them was a highlight for us all. Many of these individuals appear on the following pages (and in the exhibition itself), but we would especially like to thank Sunny Dolat, Joseph Ouechen, Mmabatho Selemela and Mouna Belgrini. We are also grateful to the British Council for their ongoing support, particularly Kendall Robbins and Niamh Tuft in the London office and Jennifer Onochie in the Lagos office.

We have benefited significantly from the generosity of funders, including the Heritage Lottery Fund, the Arts Council England Major Partner Museum Programme, the Art Fund Jonathan Ruffer Curatorial Grants Programme, and our longstanding supporter, the James Henry Green Charitable Trust.

Helen Mears, Martin Pel and Harriet Hughes,
Royal Pavilion & Museums, Brighton & Hove, UK.

Navigating the Fashion Cities of Africa: Notes from a Flâneur

Binyavanga Wainaina

Most of my clothes are made in West Africa. For twelve years now, I have had clothes made in Abidjan, N'Djamena, Dakar and Accra. I now have a set routine. If I am in one of these countries for three days or more for work, I save the first morning, ignore jetlag and hangovers, and head off to the markets to buy as much fabric as my per diem allows. For 200 dollars, you can fill a suitcase with clothes. For men, two kinds of tailors are important: the rarest are those who can make a well-cut suit. The other is the one who is generally versatile for men and women and can make good shirts, tops and trousers. All of these cities have markets where you can buy nearly any kind of fabric: linens, silks, cottons. Wool maybe not so much.

To achieve all this, you have to have an inner ninja. The most important ninja skill you need is a method to steal the loyalty of your friend's tailor. Because most tailors are men, my strategic advantage is that many tailors cannot handle the scrutiny of their female clients. Many women's clothes go through several fittings, rearrangings, and open warfare that is perpetual. Many Ghanaian tailors are notorious for wanting to remove the breasts of women, the curves of women. So I always get a woman-friend's tailor – it is easier for them to run up a few shirts for me. If I like what they've done, I always overpay – this way the work is well-finished. It's smart to have three or four tailors working at a time if you have a lot of fabric: there is nothing worse than having your pieces held hostage. Three-hundred dollars is more than enough for a full wardrobe – I pay a 60 per cent deposit upfront. I never go to markets alone – there are no ninja moves I have that are more deadly than those that market-women have. I usually hire a guide for a small fee, a local fashion-loving young man who knows the local language to negotiate fabric prices, and to help me consult with tailors.

Avoid Senegalese tailors in Abidjan. Things are rushed, and often not well-finished. Malian tailors anywhere are golden. Lagos tailors are the best when you need simple shit done well and fast – even in front of you. Carry photos or clear drawings of what you need. Always go back to fit the garment before it is completed.

I have had a certain fantasy for years. That Accra, Lagos, Dakar and Abidjan will build giant workshops near their airports where hundreds of amazingly trained tailors work and where you can arrive, buy fabric and order clothes. Imagine in these same spaces, hundreds of young designers retailing ready-to-wear lines and bespoke consultancies.

More recently, I have started to use young designers. There are many new designers with original cuts who make unique things. My favourite designer now is Chioma Chukwulozie in Lagos, who is really versatile and who has a range of beautifully cut and finished black and red bespoke caftans. Long caftans are excellent for walking as if you are gliding, and send a nice soft breeze up your legs as they swish. Because I love clothes so much, I will hitch up my caftan one day, and ride my team of goats to the stars, and through the ancient secret visa processes of Timbuktu, where I shall make a startup of design funkiness and become a member of the secret maps of the West African clothing mafias.

Binyavanga Wainaina is an African writer based in Nairobi who likes making new wardrobes.

Introduction

Hannah Azieb Pool

Fashion Cities Africa is a celebration of the contemporary fashion scenes of four key cities, namely, Nairobi, Casablanca, Lagos and Johannesburg. *Fashion Cities Africa* is not an academic text or an exhibition catalogue, nor is it a definitive guide to 'African fashion'. But what I hope it provides is a glorious snapshot of four very different African fashion landscapes. I invite you to meet the maverick designers of Casablanca, the luxury jewellery makers of Nairobi, the Johannesburg fashion collectives, the catwalk queens of Lagos and many others.

While celebrating African designers and makers, I wanted to highlight the fact that there really is no such thing as 'African' fashion any more than there is 'European' fashion or 'North American' fashion. But there are vibrant African cities, each with different influences, inspirations and priorities, all reflected by their own designers.

Inspired by and in collaboration with the Brighton Museum & Art Gallery exhibition of the same name, the book is a perfect companion to the show, but is written as a standalone text, and will go on to have a life of its own. Limitations of space within the exhibition and the publication meant we needed to settle on four cities to feature. After much consideration, Nairobi, Casablanca, Lagos and Johannesburg were chosen, as much for their diversity – regional, geographic and economic – as for their strong fashion credentials.

I wanted to capture a sense of the breadth and scope of the African fashion renaissance through the prism of these four cities, giving the reader context and analysis of where the industry is at this moment in time in each city, and where that city fits in the wider fashion landscape. I also wanted to challenge the stereotypes about what constitutes 'African' fashion and to change the visual narrative of the 'African' aesthetic.

INTRODUCTION

Each city has its own chapter, with an essay, five standalone profile interviews and a series of original portraits and street-style images, taken on location, by a photographer based in that city. Our four photographers: Sarah Marie Waiswa (Nairobi), Deborah Benzaquen (Casablanca), Lakin Ogunbanwo (Lagos) and Victor Dlamini (Joburg) have done a great job of using their city as a backdrop, letting them breathe and have their own personality.

In each city, my co-writer Helen Jennings and I found recurring themes, as designers, stylists and fashion writers told us about their joys and frustrations within the industry. Whether in Nairobi, Casablanca, Lagos or Johannesburg, fashion is a pillar of identity, a way to take risks and contextualise a sense of place. Across the continent, and its diaspora, intergenerational conversations are happening through the medium of bespoke caftans, contemporary Maasai beadwork and loom-spun *ase-oke*. Fabrics such as *kanga* (Kenya) and *adire* (Nigeria) are reimagined in contemporary ways by designers, stylists and bloggers alike. Likewise, the fashion-conscious African diaspora, with their love of all things Afro-centric, are influencing the wardrobes of those back home, who a couple of years ago would never have dreamed of wearing wax print with their skinny jeans.

In each city there are of course more designers, subcultures and styles than we were able to feature, but I am incredibly grateful to everyone who gave us their time, and to the teams at Royal Pavilion & Museums and Intellect Books for making this happen – thank you. For too long books on African fashion have been written by anthropologists and ethnographers, rather than those who live, breathe and above all, wear it. I hope this goes a little way towards redressing the balance.

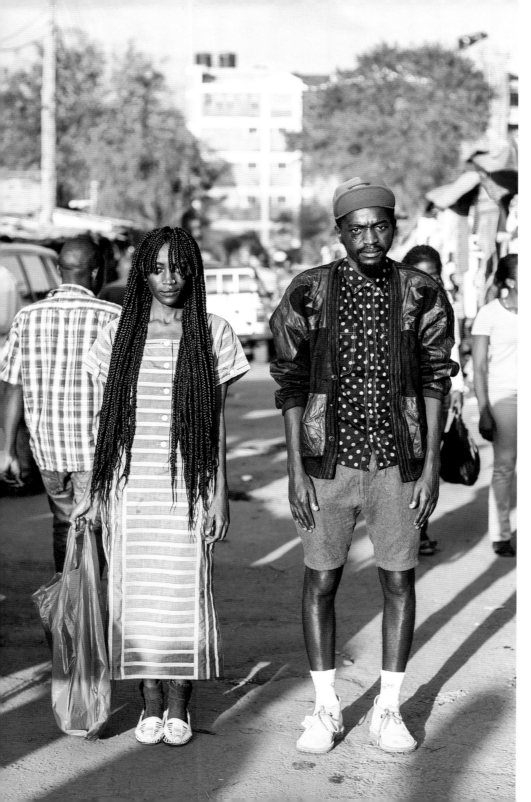

NAIROBI

Hannah Azieb Pool

It's 10am, on a crisp, clear Nairobi winter's morning. Style bloggers Velma Rossa and Papa Petit, aka Oliver, are dressed down, in jeans, T-shirts and shoes that can take a good pounding, darting through tiny, crowded lanes that separate wooden shacks piled high with clothes. Velma and Oliver – better known by their blog title, *2ManySiblings* – are bobbing and weaving through the lanes, like fashion ninjas, stopping suddenly when a gem catches their eye: a denim jacket here, a vintage beaded purse there.

Welcome to Gikomba market, Kamukunji Road, Nairobi, Kenya. East Africa's largest second-hand clothing market, stretching out for approximately twenty acres (that's over eleven football pitches), where towering bales of second-hand clothes from Europe, North America and elsewhere and cheap Chinese imports land daily, to be split open and sold for the highest shilling. Gikomba is not for the faint hearted.

'Wear comfortable clothes you can move around in,' says Oliver, when they agree to take me to the market. 'Dress like a street urchin so people don't think you have too much money,' adds Velma. When we meet the next morning Oliver looks up and down at my scruffy jeans and T-shirt and says: 'Great. You've dressed perfectly.'

To the untrained eye, Gikomba is chaos, but once you get your head around the sheer scale of the place, it's not that different to Topshop on a Saturday afternoon. The bale houses are in one section, the stalls in another. Men with trolleys take the bales to the stalls, others carry them on their shoulders.

In many ways Gikomba mirrors any urban high street. Stalls are grouped by category. Womenswear, menswear, children's clothes, shoes and accessories each have their own, vast section. You'll find stalls selling only denim skirts, rows of belts and a huge mountain of white shirts, it goes on and on. In the midst of it all sit tens of tailors ready to do instant alterations. It's impossible to see more than the four or five stalls in your immediate vicinity. Luckily, this doesn't matter, because Velma and Oliver know exactly where they are heading.

For those in the know, there's an intricate system of runners – personal shoppers effectively – who'll bring the best stuff directly to you. After a quick phone call, Oliver meets a couple of his guys near the mountain of white shirts. One contact pulls a leather jacket and a pair of boots out of a rucksack for Oliver to look at. Velma is busy eyeing up the other seller's outfit. 'How much for the jumper you're wearing?' she asks, with cute smile that I sense knocks quite a few shillings off the price. Oliver walks away with the jacket, Velma gets the jumper later, when the wearer has found something to change into. The brokers melt back into the market and we carry on shopping.

Mitumba – second-hand clothing shopping is a key part of the Nairobi fashion scene. As well as Gikomba market, there's Toi, on the outskirts of Kibera, Ngara and many smaller markets dotted around the city.

The ability to buy good quality second-hand imports plays a key part in making fashion accessible, and if you've got the stamina it's a lot of fun. 'I get lost in Gikomba, it's like going to a casino. You're just there, spending hours and you don't notice,' says Oliver. Stylist and designer Franklin Saiyalel, is another fan of *mitumba*. 'Everything I'm wearing, apart from the shoes, is thrift,' says Saiyalel whose blog *KenyanStylista.com* has won him the moniker 'Kenya's best-dressed man'.

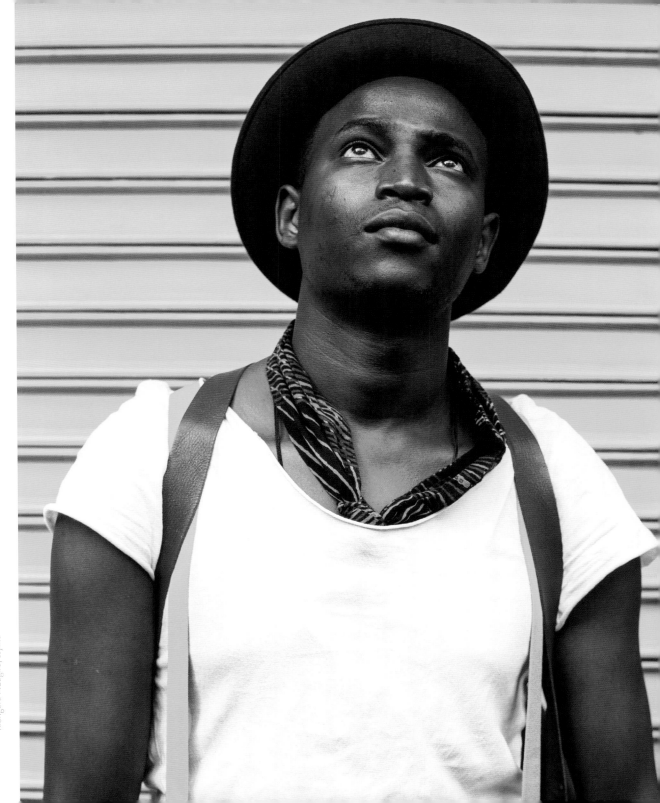

Kiongera Ndugire, stylist

'I started 100 days of African fashion to show people that in a normal environment, in an every-day context, you could wear African fashion.'

DIANA OPOTI, FASHION PR / FOUNDER, 100 DAYS OF AFRICAN FASHION

Blinky Bill, music artist

But Nairobi's fashion crowd have a mixed relationship with *mitumba*. Some see it as a great way to democratise fashion, enabling those with less money to buy essentials at knockdown prices and those with a good eye to pick up on-trend bargains. Others see *mitumba* as damaging to local industry, flooding the market with other countries cast offs and making it impossible for local designers to compete on price.

While many wear their thrifting skills with pride – Velma and Oliver for example bring *mitumba* to the cool kids, minus the mud and hassle, with regular 'Thrift Socials' – even those who love it are keen for Nairobi fashion not to be reduced to *mitumba*.

Back in downtown Nairobi, on and around Biashara Street, is the area once known as the 'Indian Bazaar'. Here you can pick up fabric and give it to a tailor who'll take your measurements and have an outfit ready in a couple of days for a few hundred shilling.

Roshni Shah, of Haria's Stamp Shop, and her family have been selling fabric on Biashara Street since the 1920s when her great-grandfather would import material from America and Japan. In recent years she's noticed a new generation coming into the shop buying East African fabrics such as *kanga* (a brightly patterned cotton cloth printed with slogans), *kitenge* (similar to a *kanga* but with a different style of pattern) and *kikoy* (a striped, woven cotton fabric) to take to their tailor. For a long time the *kanga* was relegated in most people's minds as the cloth their mother wore to clean the house, or wrap them in as a child. But along with *kitenge*, *kanga* are enjoying a new popularity as a fashion item, says Shah.

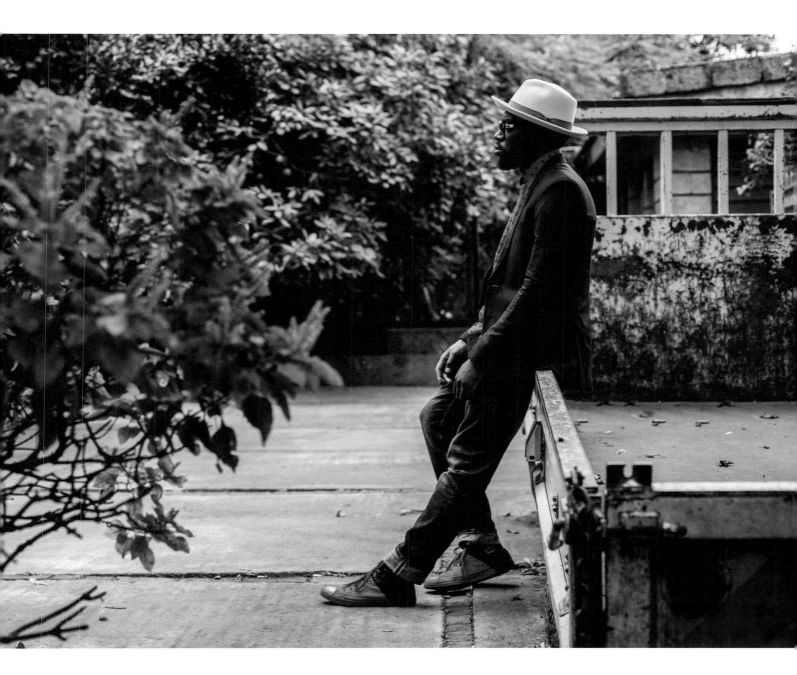

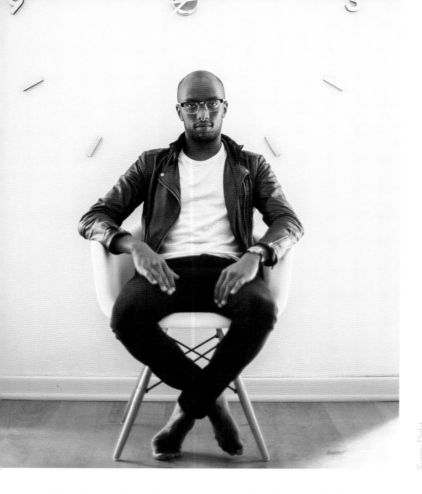

Sunny Dolat

'In Nairobi you'll find a whole bunch of fashion movements from bohemian, to minimalist, to people who are very grunge.'

SUNNY DOLAT, STYLIST / FASHION CONSULTANT, THE NEST COLLECTIVE

'People are using African prints to pull off western looks,' says Shah, who spoke on the history of *kanga* at the Smithsonian Folklife Festival in 2014. Given the culture of tailoring, the accessibility of *mitumba* and the dominance of foreign labels, Nairobi can be a tough place to cut your teeth as a designer. All of which makes the current fashion buzz in the city even more exciting.

'There's a renaissance happening in Nairobi. The creative industry is doing extremely well and that's affecting the fashion scene,' says stylist Sunny Dolat, who runs Chico Leco, The Nest artists collective's fashion hub, who won an award at the Berlin Fashion Film Festival with their short film *To Catch A Dream*. Starring one of Kenya's best-known models, Ajuma Nasenyana, and eight of Nairobi's leading designers – Katungulu Mwendwa, Kepha Maina, Namnyak Odupoy, Jamil and Azra Walji, Ann McCreath, Ami Doshi Shah and Adèle Dejak – *To Catch A Dream* is a celebration of local talent.

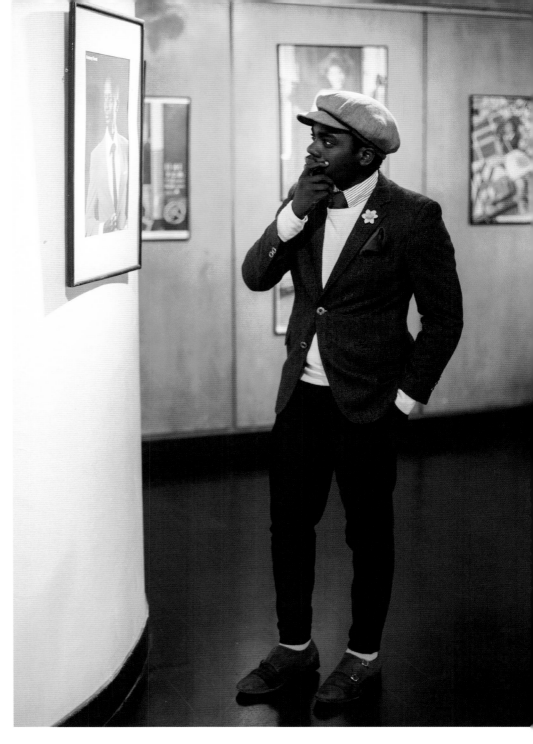

Kevin Abraham, fashion stylist / designer

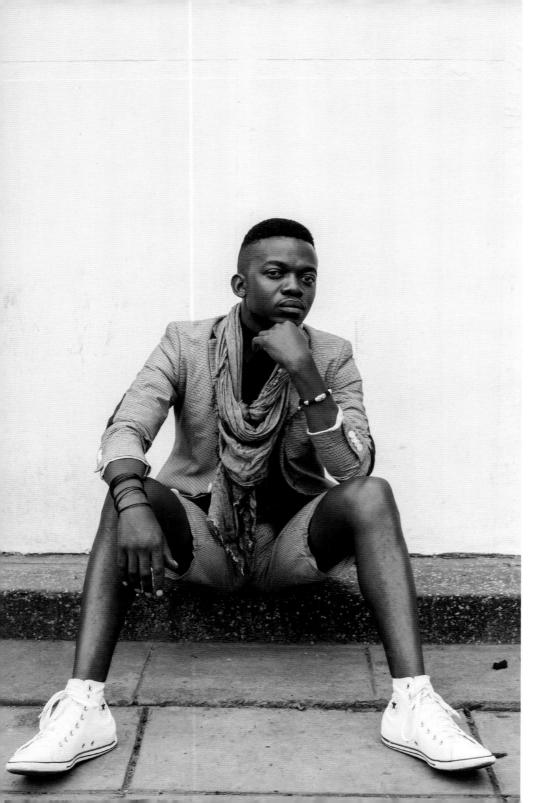

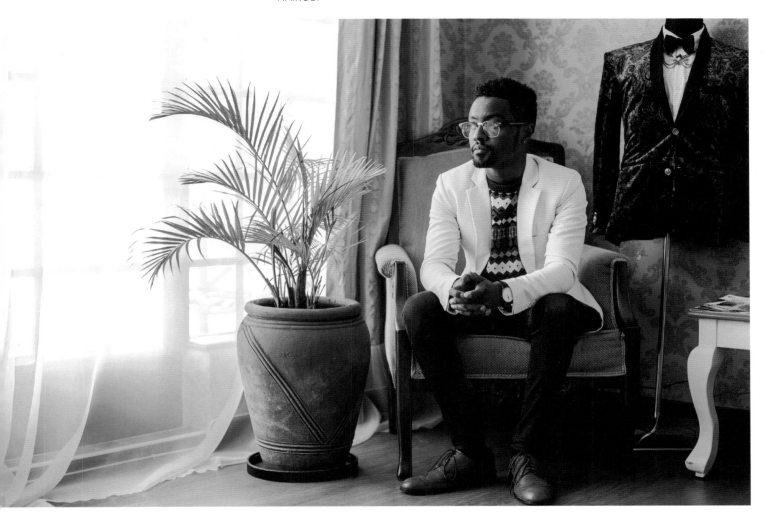

'I get people's wives emailing "oh I need you to dress my husband", or "where do I go to get this?"'

FRANKLIN SAIYALEL, BLOGGER, (KENYA STYLISTA) / STYLIST / DESIGNER

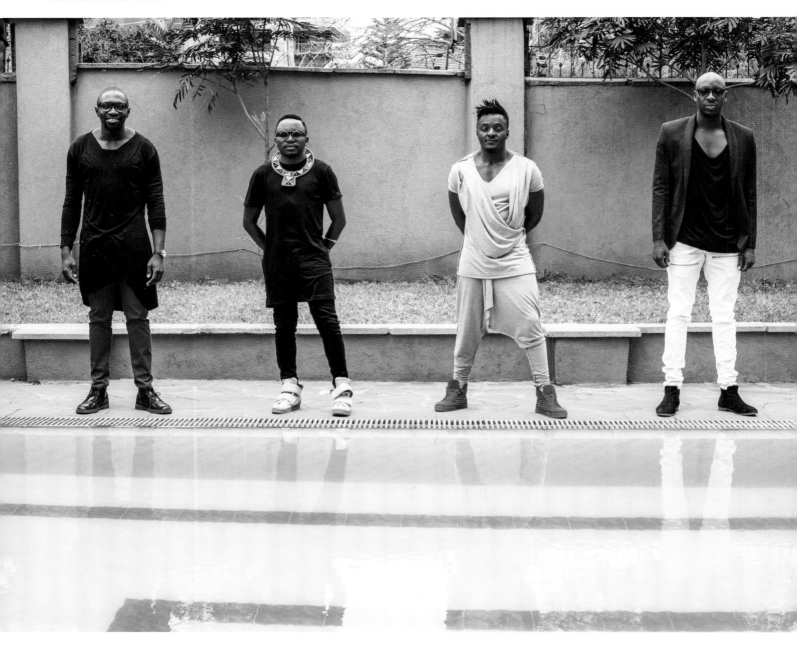

'We feel incredibly privileged to inhabit this space within fashion where we are allowed to experiment and play. We've been able to form synergies of expression with our favourite designers, all of whom are local so that we can all evolve together as artists.'

SAUTI SOL, MUSIC ARTISTS

The film, alongside platforms like *2ManySiblings*, *This is Ess*, *Kenyan Stylista* and the rise of bands like Sauti Sol (the video of the band dancing with Barack Obama went viral), who wear cutting-edge local designers like Nick Ondu on the international circuit, shows how much Nairobi fashion has changed in recent years. 'Kenyans are very conservative. Because of how we were influenced by the British, a suit and tie is what goes. If you walk in with something different, people don't seem to understand you or don't take you seriously. But things are changing,' says John Kaveke, one of Nairobi's most established menswear designers.

The flamboyance that, for example Lagos or Accra might be known for, isn't big here, says Sunny Dolat at The Nest. 'Growing up, we were never really taught to express ourselves through clothes, we've been very conservative,' says Dolat.

The blame for this conservatism lands squarely at the feet of the British colonisers and missionaries, who banned a lot of indigenous Kenyan clothing. This colonial fashion hangover meant that people were encouraged to aspire to foreign labels, as a result the domestic industry suffered, says Dolat. 'But people are starting to shift their mentality to see the value of investing in local designers and local brands,' says Dolat. Hang out with the Nairobi fashion crowd and it's not long before you'll see *kanga*, *kitenge* and *kikoy* as well as West African *ankara* and *kente* worn with skinny jeans and trainers, styled as maxi skirts and blazers or in other contemporary ways.

Sauti Sol

Lyra Aoko in Kepha Maina, photographer / blogger

John Kaveke

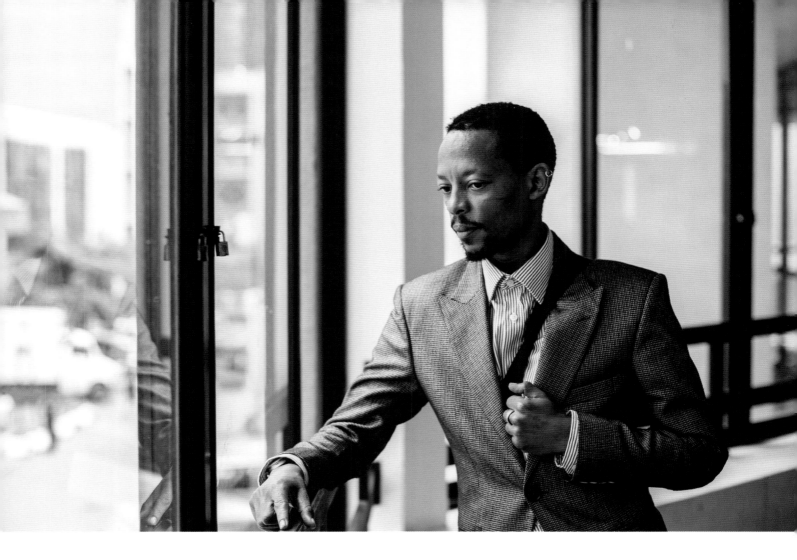

'I love using *kanga* because it's always been a domestic piece of fabric, but I want to make it luxury.'

JOHN KAVEKE, DESIGNER

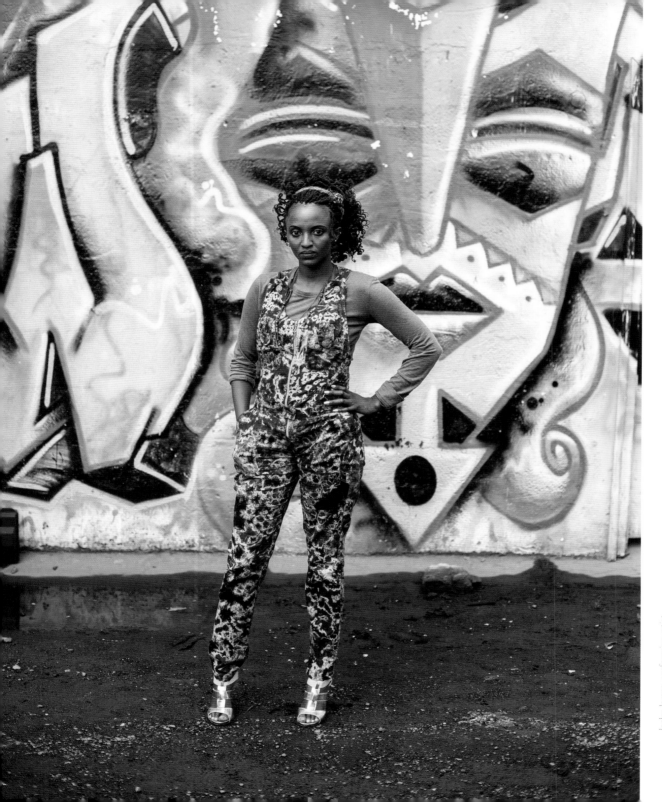

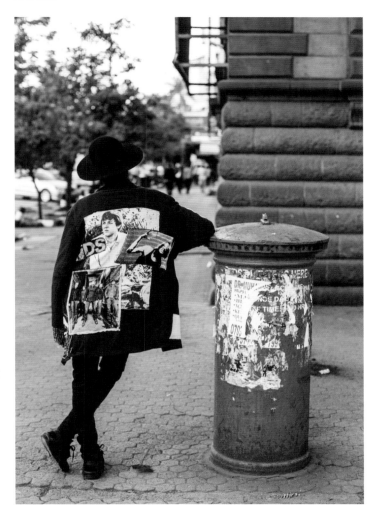

Glenn Ndivo, thrifter / fashion upcycler

Higher-end Nairobi labels such as Ann McCreath's Kiko Romeo and John Kaveke come with great tailoring and a fresh take on traditional fabrics. Accessories designers such as Ami Doshi Shah and Adèle Dejak are unashamedly rooting their brands in Nairobi by sourcing local materials to create bespoke pieces of such beauty that they smash the tired stereotype that Africa 'doesn't do luxury'.

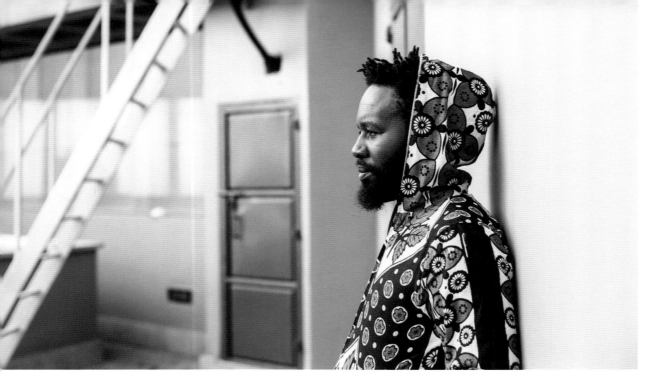

Mutua Matheka, photographer

Many are re-framing what it means to be a Kenyan designer by pairing fabrics like *kanga* and *kitenge* or locally-sourced leathers, with contemporary silhouettes. You'll find patches of Maasai *shuka* blanket reworked into an evening clutch bag by emerging label ZikoAfrika or *kanga* lining on a John Kaveke blazer. Designers like Katungulu Mwendwa ('Katungulu'), with her complex but clean structuring, or Nick Ondu ('Nick Ondu – Sartorial'), with his sharp menswear are giving this new breed of 'experimental' Nairobi dresser plenty of options. Rising stars like Anthony Mulli are seeking out craftspeople, learning their skills and finding ways to modernise them for today's tastes. It's about changing perceptions of what constitutes African fashion, says Mulli, of his Katchy Kollections, which combine intricate Maasai beadwork with international seasonal trends to create bags that work as well in New York as Nairobi.

The notion of changing perceptions of African fashion comes up repeatedly. 'We don't do curios. Our whole ethos is to create beautiful products made in Africa,' says Adèle Dejak, who has shown at Milan Fashion Week, collaborated with Salvatore Ferragamo and been featured in *Vogue Italia*. 'Our pieces are all handmade, it's a piece of art,' says Dejak. Of course you can find luxury in Africa, says Mulli, it's just a matter of how you choose to look at things. 'We need to sensitise people to what we're doing and appreciating it.'

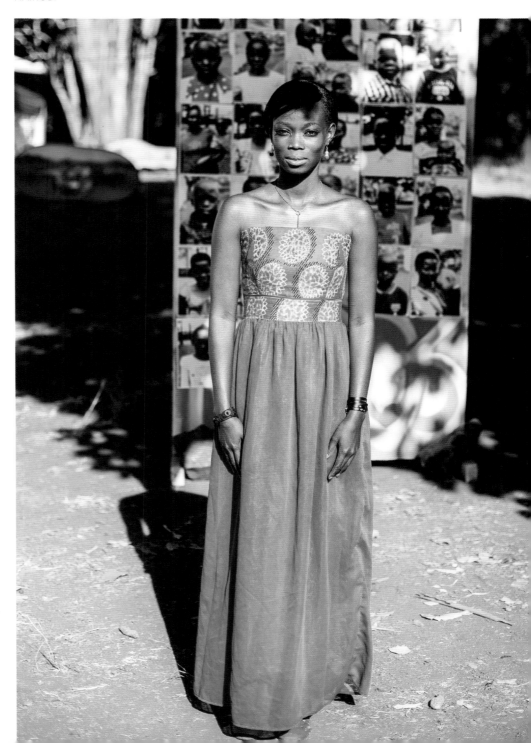

Ruth Namusia, translator

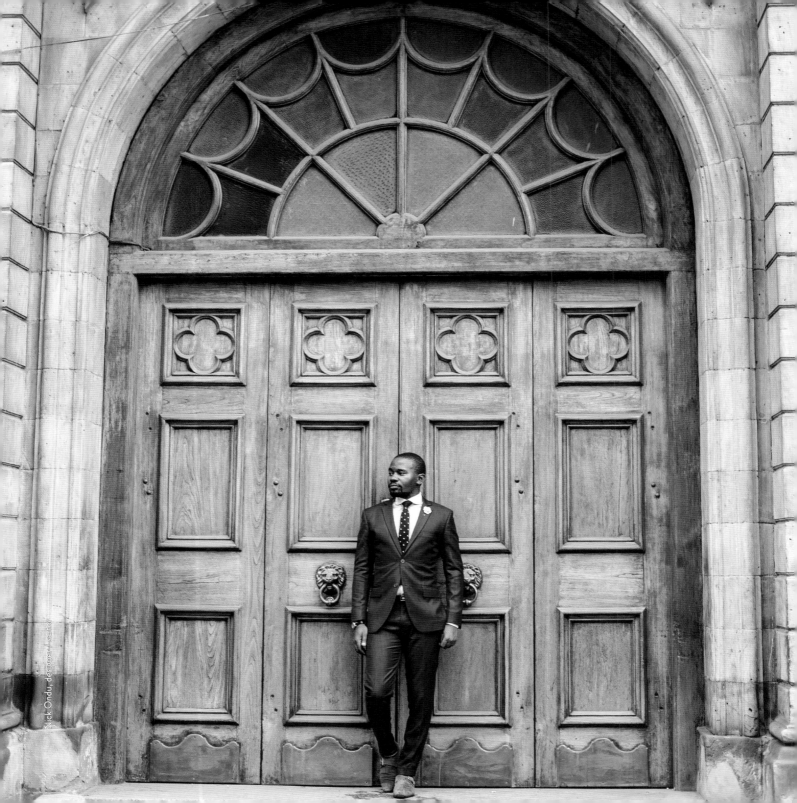

NAIROBI
PROFILES

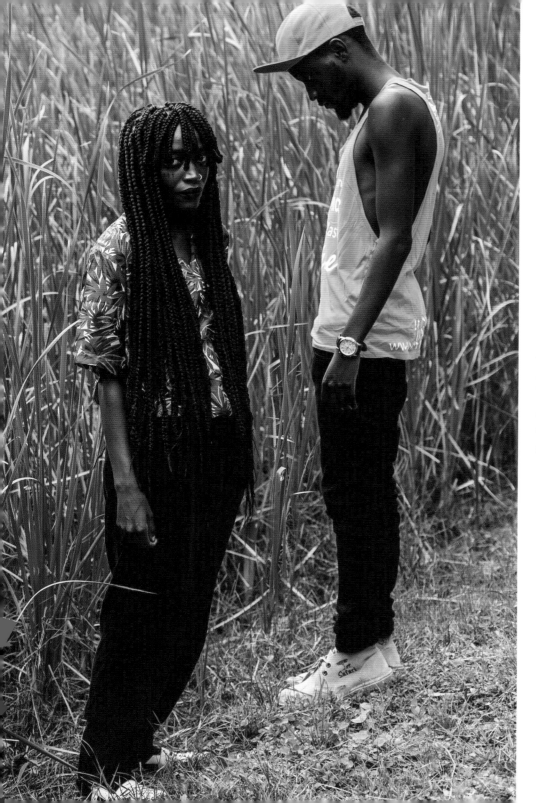

VELMA ROSSA
AND PAPA PETIT

Brother and sister Velma Rossa and
Papa Petit (aka Oliver) founded
trendsetting Tumblr *2ManySiblings*: 'a
curation space for art & photography',
inspired by the diverse city of Nairobi,
a thriving thrift culture and a rich
emerging community of young African
artists and designers.

'Our mother instilled the culture of thrifting in us when we were small.'

Velma: My look depends on what I'm feeling, how I woke up, it's just how my spirit moves me to get ready.

Oliver: I'd say mine is a work-in-progress, I haven't really found the one style.

Velma: We think alike, we feed off each other. We missed our calling as twins. Our mother instilled the culture of thrifting in us when we were small. For Sundays and Christmases, we used to go out thrifting for new clothes. They were some of the happiest moments of our lives. We just grew up with that mentality. We started using social media to tell stories through positive imagery, but also just having fun with it, showing that Nairobi has something going on… yeah, we're here!

Oliver: We love the flea markets of Nairobi – especially Gikomba and Toi markets; that's where we get most of our stuff, that and local designers.

Velma: I love designers like Adèle Dejak and Katungulu.

Oliver: Menswear is trickier, but Nick Ondu is doing some great stuff. When we started the blog, we didn't even know what direction it would take, if it was going to be strictly fashion or art, and it just became a mix. We're people who stand for culture because culture is deeper, and that's what we try and portray.

Velma: One of our core principles is promoting African photography and talent. We end up being the muses for photographers who each have a different aesthetic approach to how they shoot. There's a new breadth into how people are inspired and how they choose to dress; I feel people are really inspired to just not conform, but actually dress their character and who they've always been, you know; it's just a new wave, it's exciting times.

'We love the flea markets, that's where we get most of our stuff, that and local designers.'

PAPA PETIT (AKA OLIVER)

Oliver: Not only in fashion, but also in the creative field, it's exploding, it's a new era. As a stylist I like Nairobi subcultures, when people don't feel like they have to conform or be so safe.

Velma: When I wake up, I just want to dress and go, braiding my hair keeps it in control. I wanted a style that felt like an extension of my character, like my inner-self. I used to wear weaves, but I found that when I did braids, I felt complete.

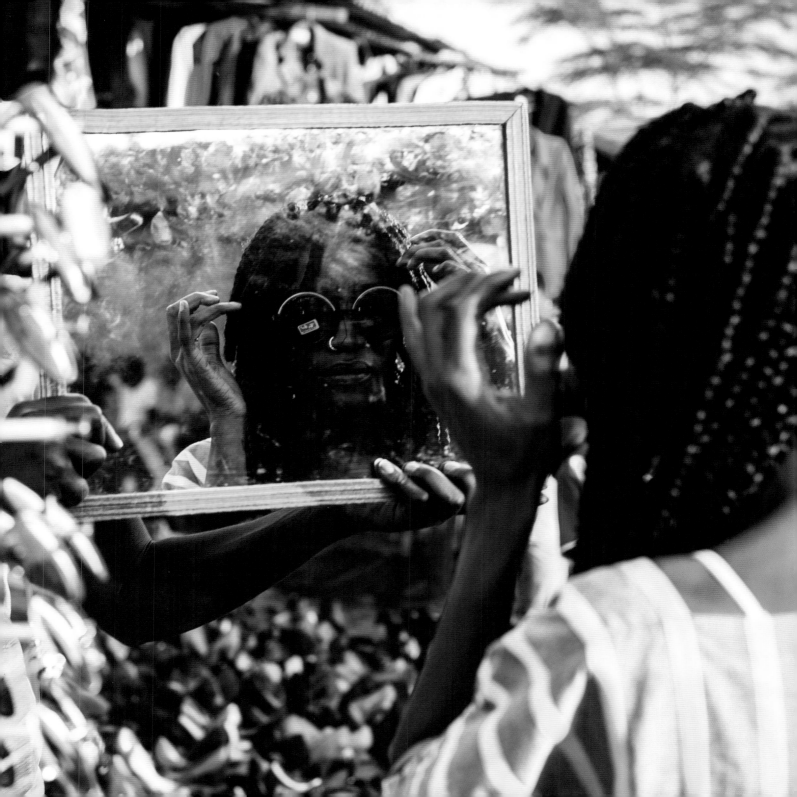

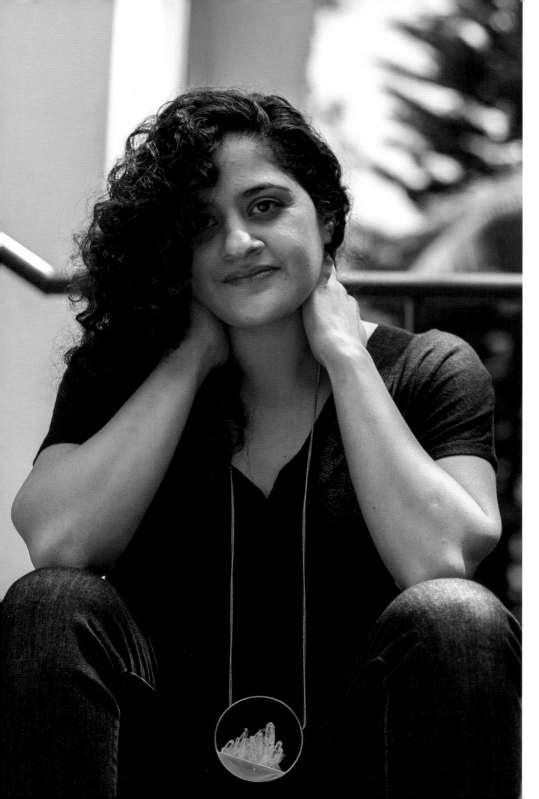

—

AMI DOSHI SHAH, I AM I

Ami Doshi Shah is a designer and founder of the jewellery brand I Am I. Her intricate and elaborate statement work is influenced by a coming-together of her African and Indian heritage with a classical European training. Shah was also runner-up of The Festival for African Fashion & Arts (FAFA) Insight, 2013 edition.

'I've got a very mixed-bag of influences and inspirations because of my Kenyan-Indian heritage and they are all reflected in my work.'

I was born in Mombasa. I'm a third generation Indian in Kenya. My grandfather came here in 1912, from Gujarat, India. A lot of Indians were brought here by the British, primarily to work in the banking sector, because Kenya and India were both part of the Commonwealth – my grandfather came as a clerk.

He came by himself and then he went back to India, married my grandmother and then they both came back to start their family in Mombasa. My husband is also Kenyan Indian.

I've got a mixed-bag of influences and inspirations because of my heritage and they are all reflected in my work. My African heritage comes out in the scale, the materials and the proportions of things. In terms of the Indian side, it's very much about the detail and the intricacy and I guess a little bit of the nuances. I studied at the School of Jewellery, Birmingham, UK, which

is classically European, it's very pared down, simple lines. These influences are all reflected in my work and complement each other. For me it's always a play on textures and materials. That contrast between hard and soft, shiny and matte, between bright colours and very dulled metals or wood and leather. I use a lot of leathers because they are a tactile material that's readily available here. For my material bases I pretty much source everything from Kenya and by default those things are sourced from the continent, the stones are also from the continent.

People don't really understand where African adornment came from, its tribal and societal significance. Over time it's been diminished through colonisation and globalisation. But most adornment was entirely shaped from the earth; it was wood, mud, entirely natural materials, and that's what I want to reflect in the materials I use.

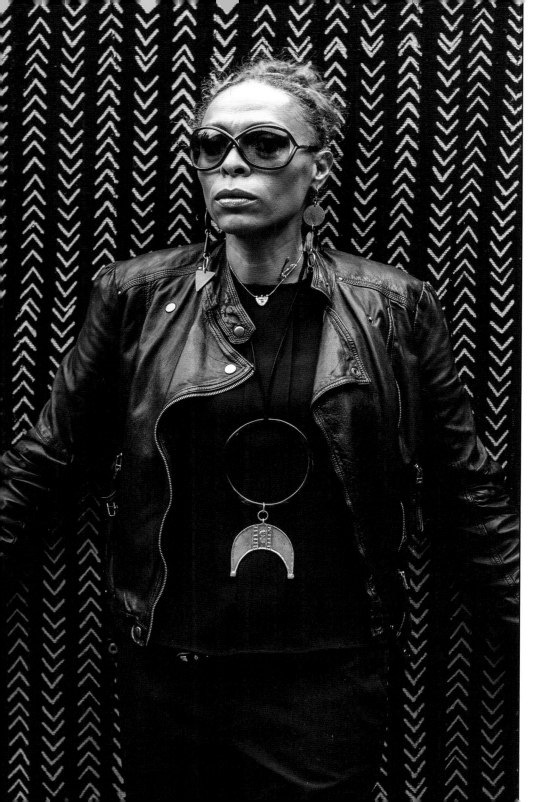

ADÈLE DEJAK

Adèle Dejak is the founder of luxury cutting-edge accessories and lifestyle brand 'Adèle Dejak'. She has shown at Milan Fashion Week 2012, collaborated with Salvatore Ferragamo, and been featured in *Vogue Italia* (2012).

'Jewellery isn't just to be worn, it's a decorative piece of art.'

When I begin a new collection, it always starts with Africa. Initially, the brand was very over-the-top, very 'statement', because I felt I needed to be heard. I've mellowed a lot, although I still create a lot of very dramatic work. You can wear my pieces, you can adorn yourself with them, but you can also adorn your house or your coffee table. Jewellery isn't just to be worn, it's a decorative piece of art, and that's what I've always done.

While I was in Uganda, I fell in love with Ankole cow horn; I use a lot of that in my pieces. It's such a beautiful form, natural, organic; it's stunning. I'm usually decked out in my cow horn, it's a natural art form. It's recycled and reclaimed, we source and get it washed in Uganda, and then polish and finish it here in Nairobi. It's lovely, like an abstract painting.

Plagiarism here is the biggest challenge. The other problem is sourcing. Our pieces are bought by Kenyans and by the expat community, everyone really. The main frustration is people not understanding that something handmade in Africa can be bespoke or luxury. We're not 'curio'. Twenty years ago, in any African country, if you were to look for jewellery you'd see the same things, because they're just catering for a European or American market; as a result, there's this notion that Africa doesn't do luxury.

I want people to see another side to the one they've seen in films from the 1950s and 1960s, all those stereotypes. Today's Africa has a different aesthetic, it's Africa, full of talent and beauty.

ANN MCCREATH, KIKO ROMEO

Scottish born Ann McCreath, founder and designer of high-end ethical womenswear label Kiko Romeo, is also the chair and co-founder of FAFA (Festival for African Fashion & Arts). Winner of the 2013 Nairobi Wonderland International Designer Award, McCreath was also a finalist in the Ethical Fashion Forum Source Awards 2012 for Outstanding Contribution to Sustainable Fashion.

'With fashion one can create something of tremendous beauty.'

When you live here, you start interacting with it in a different way, the creative energy here is so vibrant. I came to Nairobi in 1992 and never moved back. I started the label in 1996. I'd noticed Kenyans weren't wearing anything African-inspired, let alone Kenyan-inspired, and I thought that was to do with the fact that they couldn't find any African ready-to-wear cut in a western style, and Kenyans are used to wearing western styles. I also wanted to create employment, not just in Nairobi but in rural communities.

I started with my own workshop in Nairobi, because I found outsourcing stitching was a nightmare, the quality wasn't good enough. I trained in couture in Italy and I'm very good at pattern cutting. I made all the patterns myself and then I trained people how to cut. Initially, I had one tailor, but the other workers were a gardener, a carpenter, a security guy, and my sales staff were house-helps.

I've adapted things according to availability in the market, but that becomes a problem when you present a collection and you want to be selling it six months later. You either have to stock up with prints and things upfront, or you can't get them again. At the moment, I'm doing a lot of hand-painting, hand-knitting and beaded belts. About 60–70 per cent of my customers are Kenyan. I have a lot of South Sudanese. I also have Zimbabweans, South Africans and Nigerians. I do get white clients as well, lots of French.

For me, fashion becomes a political thing. FAFA was a response to post-election violence, it was a rallying call, it was me using my position as a citizen who had a profile, trying to figure out what I could do to help bring about peace. I do a lot of messaging in my shows. There's so much negativity going on, but the arts pull us up above all of that. With fashion, one can create something of tremendous beauty, which gets people thinking more positively.

ANTHONY MULLI, KATCHY KOLLECTIONS

Designer Anthony Mulli's label Katchy Kollections uses traditional techniques of craftsmanship to create unique contemporary pieces. Winner of FA254 Africa's Best Upcoming Fashion Designer in the African Designers for Tomorrow (ADFT) competition, Mulli's work has been showcased on eBay Fashion.

'I am taking traditional skills and using them in a modern way, but still keeping parts of the heritage alive.'

I was sixteen years old when I started making jewellery. Out of boredom over the holidays I asked my mum to buy me a book and a few beads, to keep me off the PlayStation. I went to a mall and picked the beads that I wanted and a book that guided you on how to make necklaces and earrings. That evening, I made my first piece – a necklace.

That same year, my sisters were graduating so they had prom. I told them, if you get me a few of your friends I can accessorise them for prom and give you some commission. Then, my mum started wearing my pieces to the office and people started asking her, 'where did you get your beads from?', and she'd say, 'oh my son makes them', and soon they were placing orders.

I've never had any formal training, but the leather work I've been learning through the men in the factories – they take me through the process of dyeing,

the textures I'll need. The beadwork I've learnt through women who do this traditionally, and I have found a way of making it modern. The tailoring I've learnt through tailors. The different craftsmen and women are real experts in what they do, so now I really want to strengthen it and see where we can take it, in terms of incorporating our old techniques of craftsmanship into accessories, and see how we can make it modern.

I am taking traditional skills and using them in a modern way, but still keeping parts of our heritage alive, seeing how we can incorporate them and leave a legacy, where I will be able to know what my grandmother did, or my great-great-grandmother did. We have to keep that history alive, but modernise it to fit in today's world.

'The beadwork I've learned through women who do this traditionally, I've found a way of making it modern.'

ANTHONY MULLI, *JEWELLERY DESIGNER*

Jewellery by Anthony Mulli

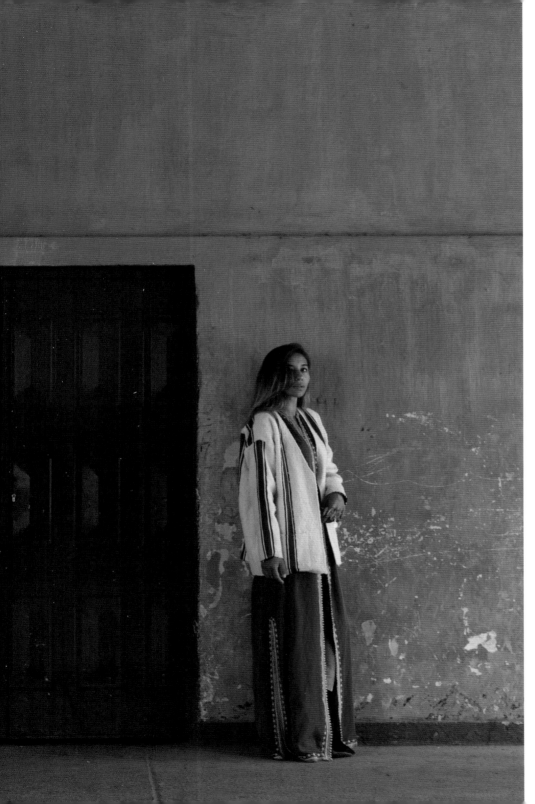

Sofia El Arabi, designer, Bakchic

CASABLANCA

Helen Jennings

'Morocco is like a sponge. We absorb from Europe, Africa and the Arab world while retaining our own roots. It's always been like that,' says journalist Mouna Belgrini, who has been reporting on Casablanca's fashion scene for a decade. 'You can choose which culture you identify with and express that through the way you dress.'

Both geographically and spiritually, Morocco has been at the crossroads of trade routes and empires for centuries, giving its creative hub, Casablanca, a unique fashion landscape. Formerly a harbour town, the French Protectorate introduced urbanism to Casablanca in the early twentieth century, including European fashion trends that were adopted by the upper classes. The Nationalist Movement embraced Moroccan attire such as *hayk* (wrapper) and *djellaba* (hooded robe) as a sign of resistance. The moderate King Mohammed V led his country to independence in 1956 but was soon succeeded by his son Hassan II whose dictatorship demanded conservative dress. Nevertheless, the first generation of fashion designers emerged in the 1960s with a fresh take on Moroccan style. Casablanca was by now a cosmopolitan city and designers such as Zina Guessous, Zhor Sebti and Tamy Tazi understood that women here were living modern lives so could not wear heavy traditional robes that restricted their movements.

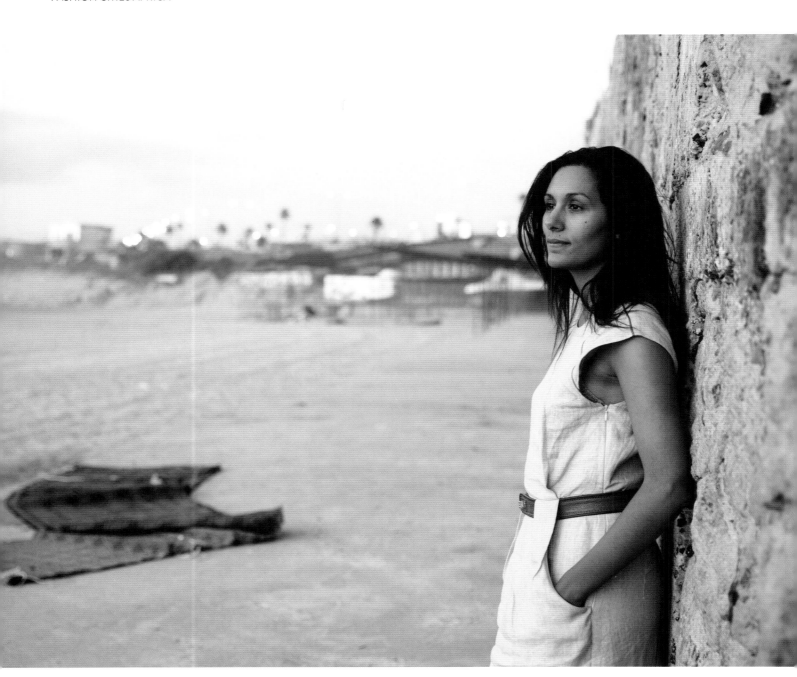

'I appreciate a woman's desire to express herself through her clothes and so I make simple pieces with powerful embroideries from Rabat and Fes.'

SAFAE BENNOUNA, DESIGNER, HE.DO

These designers therefore began to offer lighter takes on the caftan using haute couture fabrics. Tazi, who only retired in 2013, became renowned for her exquisite embroideries and textiles. She featured in US *Vogue* and also acquired the rights to represent Yves Saint Laurent in Morocco.

Saint Laurent, who was born in Algeria and had a home in Marrakech, was famously drawn to Morocco during this period along with the A-list hippy set. The likes of The Rolling Stones, The Doors, Cat Stevens and Frank Zappa all visited the country while Moroccan silhouettes influenced global trends. This in turn helped to boost the popularity of Moroccan designers at home and abroad.

By the 1980s and 1990s, a second wave of designers came to the fore. Karim Tassi, Zhor Raïs, Albert Oiknine, Simonohamed Lakhdar, Noureddine Amir, Fadila El Gadi and Salima Abdel Wahab all have their own personal takes on contemporary fashion ranging from overtly Moroccan to highly conceptual.

Zineb Joundy studied at the Chambre Syndicale de la Haute Couture in Paris and worked for Karl Lagerfeld and Lanvin before returning to Casablanca to launch her first collection of cocktail dresses in 1992. In 1996 she was approached by lifestyle magazine *Femmes du Maroc* to create a look for its debut cover and fashion show, called Caftan, which has become the country's most significant fashion event. 'I switched to caftans to cater to the demand. And also because of my wanderlust appreciation of embroideries and handcrafts from different cultures,' explains Joundy who has since shown in New York, London and Paris and become famed for her luxurious one-piece caftan. 'Today my collections are produced between Morocco and India and combine these two colourful, spicy worlds to create my brand identity that all women can wear.'

Safae Bennouna

'Casablanca's fashion scene is very calm, people are stylish and the culture is rich.'

LOUIS PHILIPPE DE GAGOUE, STYLIST

Morocco has its own inimitable art of caftan. One garment will pass through many hands and specialised crafts originate from different parts of the country. *Tarz* (embroidery), *aqad* (buttons), *sfifa* (loop braiding) and *renda* (needle lace) plus beads and sparkles can be used to embellish the robe and various metallic and silk cords including *mftal, tarssan, dfeera* and *qetan* are applied to decorate and finish the garment. They are no longer everyday attire but regardless of your religion or status, everyone wears caftan to special occasions such as weddings and Eid celebrations. The likes of Zineb Joundy and Zhor Raïs lead the way in caftan chic, by far the most lucrative and sizable segment of the local fashion market.

Since the current King Mohammed VI's ascension in 1999 there has been a growing artistic freedom, spurred on by improvements in women's rights, education, technology and the economy, and is reflected through the work of the new breed of designers. Amina Aguewany works with artisans to make spectacular contemporary jewellery, Said Mahrouf excels at fluid draping and Yassine Morabite makes edgy graphic T-shirts.

The creative scene has found its spiritual home at the Boulevard Festival, an annual alternative music event co-founded by Momo Geroni and Hicham Bahou. What started out as a 400-person party in 1999 has blossomed into a ten-day spectacular attracting 100,000. 'Boulevard is a free space where both artists and the public can come and do what they can't do the rest of the year because of society and religion,' says Geroni. 'It is about rediscovering our roots. Colonialism and a move to city living caused us to disconnect from our heritage. We had a problem with our identity. But now we are using it to create something new,' adds Bahou.

Louis Philippe de Gagoue

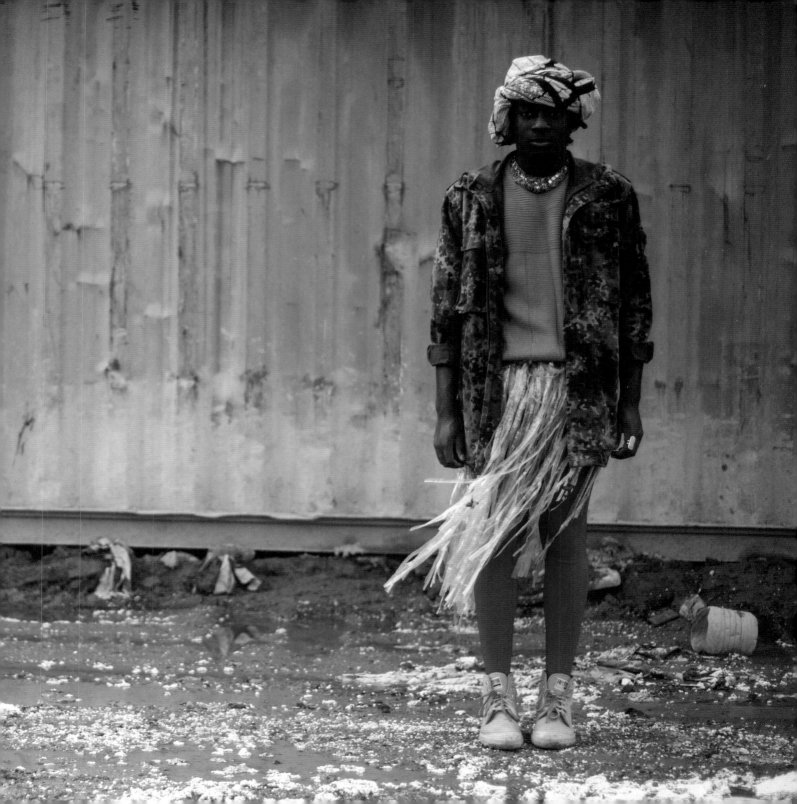

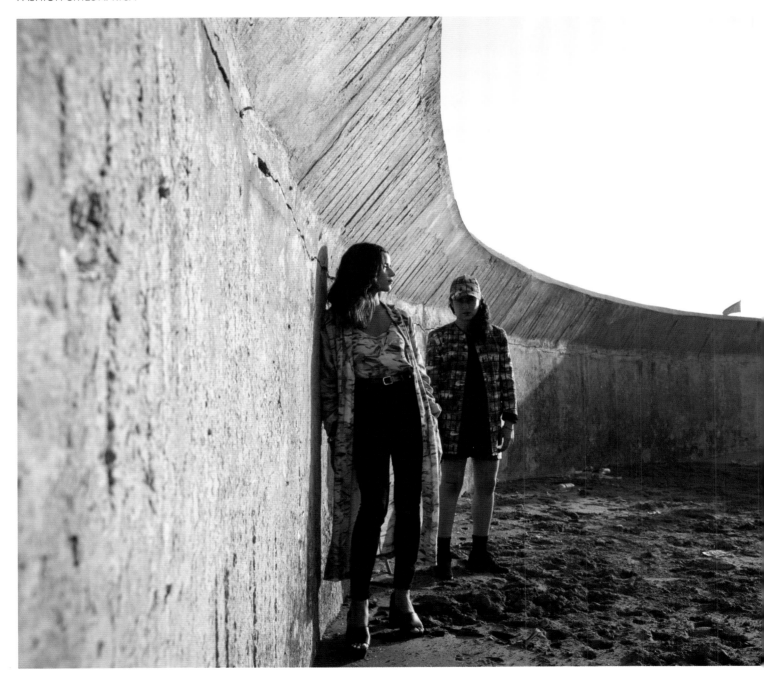

'Our designs have a meaning and a story. It's about a global way of life and bearing witness to the times we live in.'

ZAHRA AND MERIEM BENNANI, DESIGNERS, JNOUN

Zahra | Meriem Bennani

Amine Bendriouich started out selling T-shirts at the Boulevard in 2007 and is now one of Casablanca's most innovative, maverick designers. He has shown in Amsterdam, Berlin, Lagos and Dubai and reflects his society with new takes on *sarouls* (trousers) and *djellabas* and designs such as a jacket with strategic cuts in it that allows the wearer to invite their lover's hands inside. 'Here it's meant to be shameful for couples to be affectionate in public. In a perfect world, we'd admit how ridiculous this is,' says Bendriouich.

Hassan Hajjaj, who works between London and Marrakech, has been something of a mentor to Bendriouich. 'Amine takes risks, he has the talent to carry the young generation he represents,' says Hajjaj, who started out as a stylist in the 1990s and is now an award-winning visual artist and designer. His images challenge the West's misconceptions about North African Arabic society while celebrating his own multi-cultural existence. Think veiled women riding motorbikes through the medina wearing Adidas logo *djellabas*.

Ghitta Laskrouif follows in their footsteps with her line of upscaled, sustainable womenswear. 'I take details from traditional looks, such as a *mdemma* (belt) or *aqad* and use them in a different way. Recycling and remaking is what inspires me,' says the young designer who collaborated with many local brands before setting out alone in 2014.

Safae Bennouna offers grown-up elegance with her label He.Do. After working in finance, she succumbed to her true passion in 2015, developing her shapely cuts in France and production in Morocco. 'I've been a dancer since I was a child and always sketched so now I've come back to doing something more sensual and creative,' she explains.

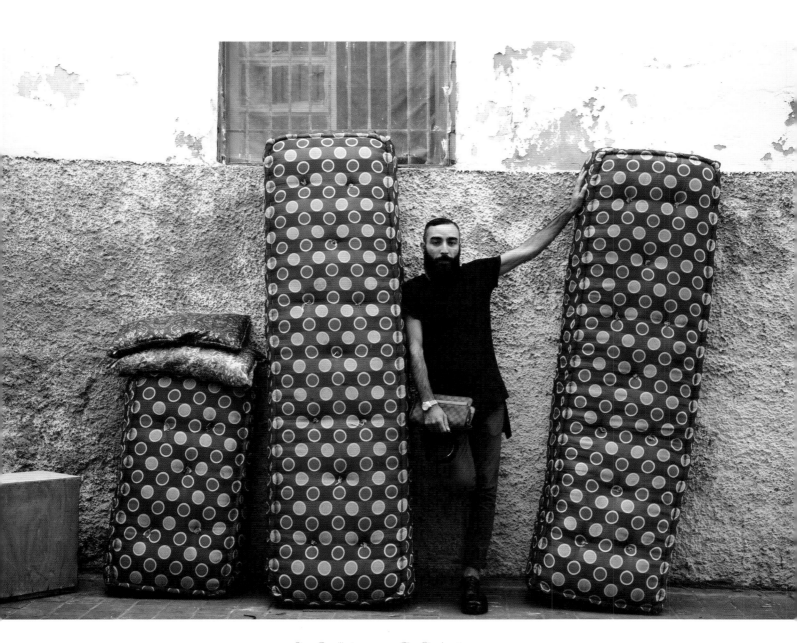

Simo Cavalli, store owner, Ciao Ciao boutique

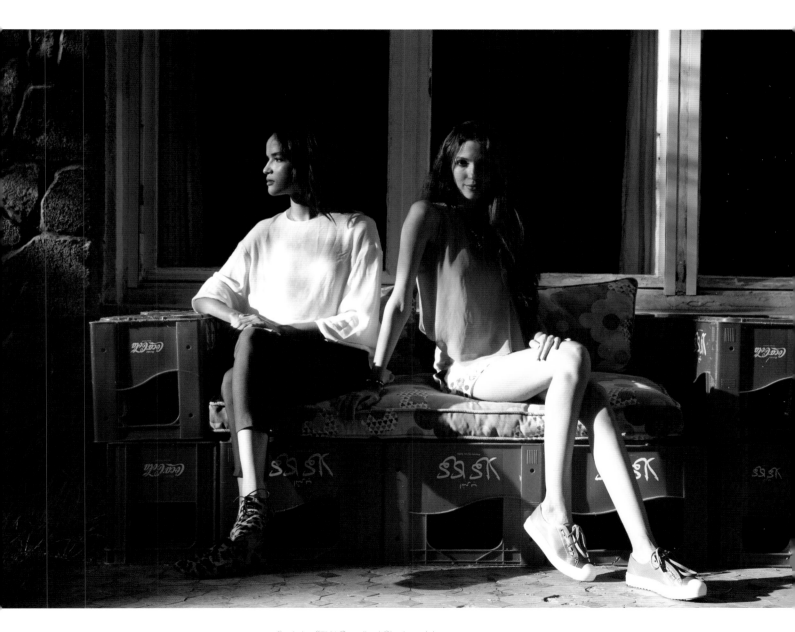

Soukaina Eljid | Camelia el Ghazi, models

Sophie Benkirane, store owner, La Galerie de L'Aimance

'I wear my grandmother's caftans with tattoos and short hair. My style is considered punk but to me it's about creating a future heritage.'

ZINEB ANDRESS ARRAKI, SCENOGRAPHER / ARCHITECT

Fellow designer Siham Sara Chraibi left a career as an architect behind in Paris to establish her atelier back home in 2012. 'The fashion scene here is moving, we are lucky to be part of the moment.'

Thanks in part to the influx of international brands (Gucci, Fendi, Zara, Mango, etc.), fashion magazines have cropped up such as *Tendance & Shopping*, *L'Officiel Maroc*, *Illi*, *Clones* and *Version Homme*. And in 2006 Festimode Casablanca Fashion Week (FCFW) was established to promote contemporary designers. Unfortunately the global recession hit hard, magazines closed and FCFW held its last edition in 2012. But Belgrini sees a new beginning on the horizon as part of the team for *Grazia Maroc*, which launched in 2015. 'We took a few steps back but now we're moving forward with an approach that is more authentically Moroccan.'

Digital and social media is also growing, albeit gradually. Forerunners include noted street-style photographer Joseph Ouechen (*You Are The Style*) and designer and stylist Sofia El Arabi (*Bakchic*), who remakes vintage textiles into one-off boho pieces. Ivorian stylist and blogger Louis Philippe de Gagoue was based in Casablanca for several years and influenced street-style with his outlandish get ups. 'Casablanca is a beautiful and inspiring city. I would mix up *babouche* (slippers) and Berber and Tuareg jewellery with clothes from other cultures,' de Gagoue says. Other bloggers making a name for themselves include Mohcine Aoiki and Yasmina Olfi.

Zineb Andress Arraki

'My generation are just a few and
it's hard but we have to make
a change so that those who are
studying now can follow us.'

GHITTA LASKROUIF, DESIGNER

'Designing a caftan is a conversation between the body and the clothes... it's an osmosis.'

ZINEB JOUNDY, DESIGNER

Zineb Joundy

Ghitta Laskrouif

One of the biggest challenges facing designers is production. While the country possesses some of the best manufacturing capabilities in Africa, factories are focused on large orders from global brands, and are now beginning to suffer due to competition from Asia. Likewise very few shops stock local designers. An exception is concept store La Galerie de L'Aimance, which opened in 2012 and exclusively sells made-in-Morocco goods. 'I hope I am having an impact but it's hard to find creators who have the right structure behind them to be able to supply me with stock on a consistent basis,' says owner Sophie Benkirane. 'What is needed is more official funding and support for artists.'

Casa Moda Academy is trying to tackle this issue head on. The fashion college opened in 2010 with student fees part-paid by the country's textile and manufacturing industrialists. 'We want to breed excellence in the local industry by teaching everything from pattern cutting to the history of art,' says director Sylvie Billaudeau. Recent graduate Inass Saghdaoui is developing her collection of geometric womenswear. 'I want my clothes to travel around the globe,' says Saghdaoui.

One such brand to do just that is Jnoun by sisters Meriem Bennani, a video artist, and Zahra Bennani, a marketing executive. 'We produce in Casablanca because it's important to us to be part of our country's growth,' says Meriem. The duo have taken Moroccan tropes – the Sahara desert, Caïdale tents and the Atlantic Ocean – and fragmented them. 'Jnoun reflects the world we belong to. Here it's a challenge to be young female entrepreneurs but there is a dynamism and a good energy that comes from doing something new. Here there is everything to be done.'

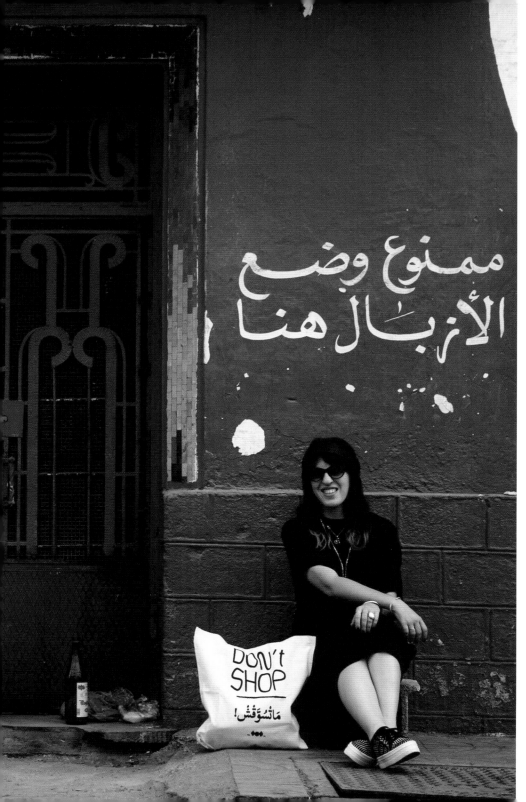

منوع وضع
الأزبال هنا

DON'T
SHOP
ماتشوقش!

Mouna Belgrini

'We draw on everything
from luxury fashion
to the underground to
make magazines for
fashionable Moroccan
women who need a
publication that speaks
to them.'

MOUNA BELGRINI, JOURNALIST

Inass Saghdaoui

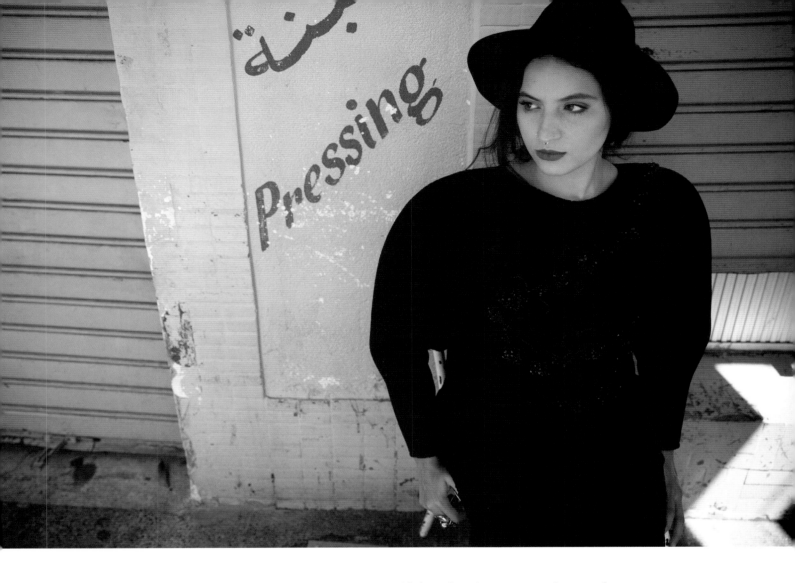

'My designs are based on geometry, ergonomics and the use of industrial fabrics to make feminine clothes.'

INASS SAGHDAOUI, FASHION GRADUATE

CASABLANCA
PROFILES

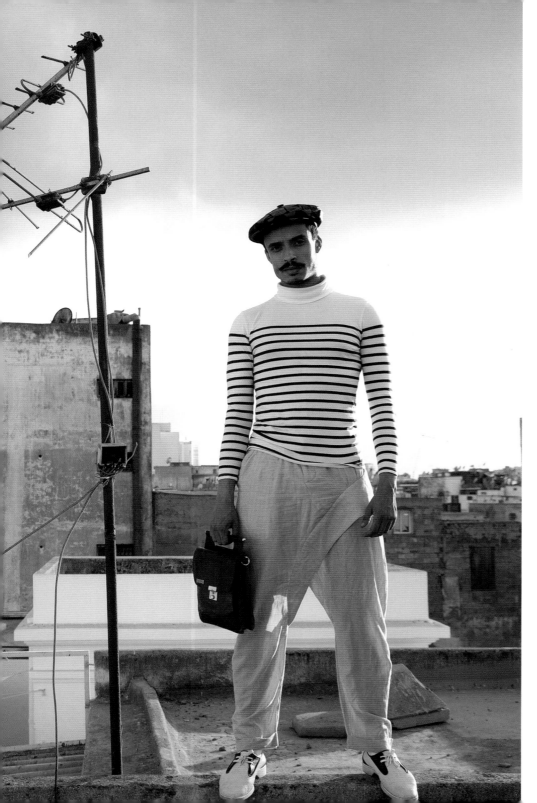

AMINE BENDRIOUICH, AMINE BENDRIOUICH COUTURE & BULLSHIT (ABCB)

Amine Bendriouich grew up in Marrakech, studied fashion at École supérieure des arts et techniques de la mode (ESMOD) in Tunisia and moved to Casablanca in 2007, where he launched his brand Amine Bendriouich Couture & Bullshit (ABCB). He's since become a pioneer with his no-holds-barred, souk-meets-streetwear aesthetic.

'I was taking a stand against the hegemony of the caftan, which had become self-exoticised.'

I started out as part of a collective making T-shirts. One design took the popular slang word *hmar* (meaning jackass) and turned it into a humorous design. It went viral and became the most popular T-shirt in the Arab world. I showed at FestiMode Casablanca Fashion Week soon after. Instead of models, I cast punks and rappers and made an anti-trends statement with a collection made in the city's slums.

In 2008 I launched ABCB and Contemporary Moroccan Roots, a multi-disciplinary event fusing fashion, art, film and music that brought together a diverse crowd for the first time in Casablanca. In 2009, I won a Goethe-Institut competition to work in Berlin for a year. I've been living between Casablanca and Berlin ever since, forming collaborations with the likes of Ebon Heath, Elyas Khan, Skrillex and Keziah Jones.

My work questions identity. I'm African, Arab, Berber, Tuareg and Moroccan. I address historical and contemporary Moroccan society, but also relate on a universal level. The collection, Ich Bin Ein Berberliner (a play on JFK's famous speech), stems from a trip to the Sahara desert that I made in 2014 with the soul musician Oum to art-direct her album. I felt this cool energy being near where my ancestors are from. I sought out the local craftswomen, who made carpets and embroideries, and spent several weeks working with them. The clothes imagine a Berber tribe being teleported to Berlin. Simple black silhouettes are covered with imperfect embroideries in strong, flashy colours.

A few years ago I was seen as crazy in my country. Now I'm on national TV and the scene is growing in an organic way. If this keeps going, we'll see Moroccan brands going out to the world.

AMINA AGUEZNAY

Amina Agueznay trained and worked as an architect in the United States, but her life-long love of Berber and Tuareg jewellery drew her home to Casablanca to embark on a new path. She has exhibited and sold worldwide as both an artist and designer and continues to push the boundaries of Moroccan artisanship.

'In Morocco you have the caftan designers and the contemporary designers. They live in two different worlds.'

My grandmother gave me my first ring as a child and my mother (Malika Agueznay), who was one of the early modern Moroccan artists, would take me to souks to buy antique jewellery. I've been collecting ever since. I come up with ways of creating, then work out what to make and collaborate with artisans to produce it.

At first I cocooned stones in precious quartz structures. I deconstructed Berber pieces and made links out of cord buttons used for a *djellaba*. I looked to nature – leather, wood, coral, *sabra* (silk), shells, paper, camel hair. Now, the sky is the limit. I often work on a large scale and create installations for the body. I have collaborated with Noureddine Amir on numerous collections.

One collection was about burning plastic and another was made entirely out of paper. I have shown in Paris and New York and was selected to represent Morocco at Maison Méditerranéenne des Métiers de la Mode.

My products don't look 'ethnic', but it's the human touch and the artisan's story behind them that is important to me. I do workshops around the country to help craftsmen innovate their skills so that they can make and market new things. In Laayoune, they have *sedwa* (wood and silver combined in layers) and *tekchar* (leather etching). And in Essaouira and Tiznit, they make filigree called *deg souiri*. Morocco is a goldmine for craft. We can't let this precious heritage die.

—

YASSINE MORABITE, ZAZLOUZ

Yassine Morabite's unisex T-shirt brand Zazlouz has become a must-have for those in the know across Casablanca. He festoons simple white vests and tops with printed illustrations of famous faces that have been given a distinctly Moroccan makeover.

'My customers are young artists and liberals who find something in my work that they can identify with.'

My father was a tailor and I always loved fashion and drawing. But growing up I couldn't afford cool clothes so I just started drawing on the ones I had to make them feel new. At first, it was surfing and skating imagery. Then I got into hard rock bands, but at the same time I was reading *Vogue*, so I'd combine the two worlds by sketching Karl Lagerfeld with a skull face. Then I became more inspired by local culture.

I didn't finish school and trained in jewellery. I dreamed of having my own fashion label but it seemed so far away. At first, I just did T-shirts for myself, but in 2008 I put them on Facebook and they got noticed. Demand grew, and by 2011 I had done my first proper collection. Galleries Lafayette arrived in Casablanca and hosted a street-style contest. I won and got to travel to France – my first time abroad – and design a T-shirt line for the department store. I now collaborate with other artists such as Amine Bendriouich, and sell at concept stores and pop-ups. Some of my recent designs include Bruce Lee with *gnawa* (Islamic spiritual music) instruments, and Cara Delevingne drenched in Berber accessories. A popular design was of Moroccan musicians Laarbi Batma and Mohamed Houari dressed like Daft Punk. It's about creating a social context and debate using pop icons.

My customers are young artists and liberals who find something in my work that they can identify with. They see their roots but also something contemporary that can be understood anywhere in the world.

—

SAID MAHROUF

Said Mahrouf was born in Morocco but grew up in the Netherlands, where he studied fashion at Gerrit Rietveld Academie. He worked as a costume designer and performance artist in Amsterdam and New York before moving into fashion in 2007. He relocated his brand to Casablanca in 2011, where he has found mainstream acclaim for his understated womenswear.

'We need platforms that bring us together and inspire young designers to feel that fashion is possible and tangible.'

As a young artist, making wearable clothes didn't interest me. My designs and site-specific performances were about changing the perceptions of a location and provoking certain movements. Each piece had intricate details that would evolve and change with the choreography.

In 2007, I was invited to make a collection to show at FestiMode Casablanca Fashion Week. It was a personal challenge. Could I make pretty clothes? I found that I could. After that I concentrated on building a successful business here. My customers are working women. They come to my atelier for something simple, minimal and toned down.

Casablanca is a modern city and it's inspiring, both in terms of the architecture and the way of life. I make no concessions in my designs to the traditional Moroccan market. My latest collection looked to Kazimir Malevich's work. I use colour blocking to reference the compositions of his paintings as well as the idea of Primitivism that one creates by feeling. I drape on a mannequin without sketching, taking a piece of fabric and following my instincts.

Today, I show in Dubai and Amsterdam but it's sad that there's no longer any fashion shows in Morocco, where designers can present contemporary clothes. We need platforms that bring us together and inspire young designers to feel that fashion is possible and tangible. The fashion industry is really at the start, but there is a lot of potential.

ZHOR, CHADIA AND AIDA RAÏS

Zhor Raïs is one of Morocco's most respected caftan designers. Her career has spanned three decades, during which time she has pioneered a slimmer, more feminine silhouette, dressed royalty and presented couture in Paris. Now, her daughters Chadia and Aida have joined the fold.

'Today, there are no rules. You can wear caftans how you like, have fun with it and feel modern.'

I grew up in a family of tailors and seamstresses. By the age of nineteen, I started making evening dresses for friends and family and hosting fashion shows at home. Back then, young women didn't want to wear caftans because they were too large and heavy, so I started making them sexy and fitted and they gained popularity. My workshops grew and grew until I moved into my current House of Kaftan in 2011, where my clients come for a luxurious, personal experience.

I want every one of my caftans to be unique, to have a specialness that you can feel when you wear one. I use traditional Moroccan techniques but also cater to the woman's needs and tastes and to international trends.

My keywords are elegant, simple, chic and sensual. We also make *djellabas*, *abayas* (full cover-ups), *gandora* (short-sleeved robes), capes, men's shirts and beach cover-ups, plus my daughters are developing a ready-to-wear line. We give all credit to our craftsmen and women – without them, there would be no caftan. Each city is known for different skills, from the buttons and embroideries to belts and slippers. Once, at a fashion show in Fes, I brought them onto the stage with me to take their bows.

Morocco is changing. Women want things that are easy and light to wear. Today, there are no rules. You can wear caftans how you like, have fun with it and feel modern.

Eku Edewor, tv presenter / actress

LAGOS

Helen Jennings

With a population of around twenty million people, Africa's most populous city has a reputation for addictive energy, entrepreneurship and extremes. Wallflowers need not apply in this sprawling metropolis where only the most suave survive. 'We are known for being rambunctious and flamboyant. But here you have to stand out. Otherwise you drown in the noise and volume of people,' says Tokini Peterside, a strategy consultant specialising in African luxury. It's little wonder then that the city's fashion scene is equally vivacious. 'Our designers cater to that vibrancy, to that zest for life that we all share. Our fashion is audacious and wants to make a statement.'

Thanks to a surge of creative energy in the past decade, fed by a growing economy (Nigeria surpassed South Africa as the country with the continent's largest gross domestic product in 2014), there is now a swell of fashion talent drawing international attention to Lagos. But the seeds of the industry were sown long ago. Set against a rich history of sartorial acumen, textile prowess and global migration, the concept of contemporary fashion took off in West Africa in the 1960s, just as it did in Europe and the US. Nigeria declared independence from Great Britain in 1960 and fashion became an expression of a renewed sense of cultural identity. A young urban elite proudly mixed European fashions with local tailor-made Nigerian styles.

'I want to see our brands consumed in the mainstream internationally. That's where they need to be.'

CHINEDU OKEKE, BRAND CONSULTANT / FESTIVAL PRODUCER, ECLIPSE WEST AFRICA

Designer Shade Thomas-Fahm is credited with introducing African ready-to-wear to Lagos in the early 1960s. Having trained at London's Central Saint Martins, she opened a series of boutiques selling modern versions of traditional styles such as the pre-tied *gele* (head wrap), turning *iro* and *buba* (loose blouse and wrapper) into a top and skirt and adapting a man's *agbada* (roomy gown with wide sleeves) into a woman's embroidered *boubou* (caftan-like dress).

This initial *joie de vive* was dampened as the country lived through civil war and a succession of military juntas. Oil revenues began to flow in the 1970s and Lagos continued to breed fashion pioneers throughout the decades before the country regained democracy in 1999. Abah Folawyio (Labenelle), Betty Okuboyejo (Betti O), Folorunso Alakija (Rose of Sharon), textile artist Nike Davies Okundaye and Funmi Ladipo Ajila dressed the well-to-do and helped establish the Fashion Designers' Association of Nigeria (FADAN).

By the noughties a more formalised fashion industry began to form, giving rise to designers including David Kolawole Vaughan (Dakova), Remi Lagos and Deola Sagoe. Sagoe is part of a fashion dynasty, her mother manufactured menswear and she set out on her own in the 1990s, opening her flagship store in 2007. While she specialises in bespoke and red-carpet looks (Thandie Newton is a fan) her daughters Teni, Aba and Tiwa launched the younger line Clan in 2011. The family showed together at New York Fashion Week (NYFW) in 2014. 'When I started out, being a designer wasn't cool, people dismissed you as a tailor. Now I see so many designers thriving,' says Sagoe. 'Fashion is part of our culture. Nigerians appreciate beautiful things and are now taking the industry seriously.' Her contemporary Folake Folarin-Coker established Tiffany Amber in 1998 with a line of tunics and caftans and her lifestyle brand is now known for elegant resortwear. Folarin-Coker collaborates with local artists such as Kolade Oshinowo on prints and her signature Lily Twist Wrap dress is a must-have for Lagos ladies. 'Now there is a huge appetite for African designers and Lagos is filling that gap,' she says.

Chinedu Okeke

'Social media is playing a pivotal role in terms of exposing talent and encouraging experimentation. I'm pushing a minimal sports aesthetic with new menswear brand MXVV.'

KADAIRA ENGESI, ARTIST

The launch of *Arise* magazine in 2008 stepped up the profile of Nigerian fashion. The London-based, Nigerian-owned title gave international exposure to the work of the best designers via its editorial pages, by hosting group shows at NYFW and organising *Arise* magazine Fashion Weeks in Lagos. Sagoe and Folarin-Coker often headlined alongside Lisa Folawiyo of Jewel by Lisa, who reinvented *ankara* as a luxuriously embellished fabric. The colourful Dutch wax cloth has been synonymous with West African style since its introduction in the early nineteenth century by companies such as Vlisco. Folawiyo and other designers including Ituen Basi, Odio Mimonet, Ere Dappa and Lanre da Silva Ajaye made it fashionable, its colourful African-inspired prints lending themselves to their feminine designs.

Now a new generation of Lagos designers continue to push the boundaries by digging into their culture to develop fresh takes on centuries-old crafts and fusing them with outside influences. Amaka Osakwe of Maki Oh has found critical acclaim for her reinterpretation of *adire*, traditionally made by Yoruba women of southwest Nigeria using indigo resist dyeing techniques. Republic of Foreigner by sisters Carmen and Selina Sutherland offers easy silhouettes inspired by the double wrapper traditionally worn in Delta State. And Bubu Ogisi of I.Am.Isigo draws on everything from the movie *Calamity Jane* to the Wodaabe Fulani tribe of northern Nigeria. 'What drives us all is the stress of living here, which actually makes you more creative. There is beauty in the chaos,' says Ogisi.

'Nigerians love lace. We wear it to celebrate and party. So I've developed my own patented local lace using hand-cut methods in our atelier.'

DEOLA SAGOE, DESIGNER

Deola Sagoe

Bolaji Animashaun, creative director, The Style HQ | Bubu Ogisi, designer, I.Am.Isigo

Hauwa Mukan

'Nigerians are the new sexy. With the spotlight being shone on our creative industry, we can grow and use it to do something positive. It's time for us to step up and deliver.'

HAUWA MUKAN, RADIO & TV PRODUCER / PRESENTER

For young Lagosians today, it's never felt more right to wear Nigerian but it wasn't always the case. 'When we were at school, everyone was into big brands – Sean John, Nike, DKNY. It was a stamp to show that you had travelled. And we didn't listen to Nigerian music. Now there's more pride in things that are African,' says Ozzy Etomi of streetwear brand Caven Etomi. Her graphic T-shirts and accessories take subtle cues from local traditions, such as the meaning of an Ibo scripture or the lines of a mask. 'We just want to make beautiful clothes with an African stamp.'

Lagos menswear has begun to catch up with womenswear too. Brands, including Mai Atafo and Okunoren Twins, offer either Savile Row-style suiting or *agbada*, caftan and *dashiki* (a loose fitting shirt). (On Fridays, professionals are encouraged to 'wear traditional' to work.) Meanwhile, newer names such as Orange Culture, Kenneth Ize and Adeju Thompson are taking a more nomadic turn. 'I'm playing with the line between masculinity and femininity to create collections that tell Nigerian stories,' says Adebayo Oke-Lawal of Orange Culture, who was shortlisted for the LVMH Prize 2014 and showed his S/S'16 collections (his ode to Lagos fishermen swag) both at Pitti Uomo in Florence and South African Menswear Week.

Temi, Aba and Tiwa Sagoe, designers, Clan

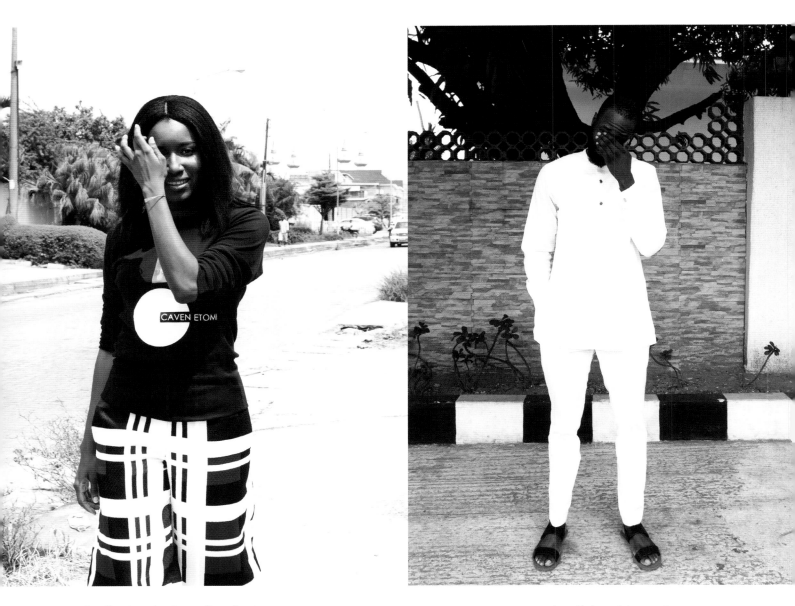

Ozzy Etomi, creative director, Caven Etomi

Lanre Masha, marketing executive

Yagazie Emezi, influencer / consultant

Dimeji Alara, journalist / fashion director

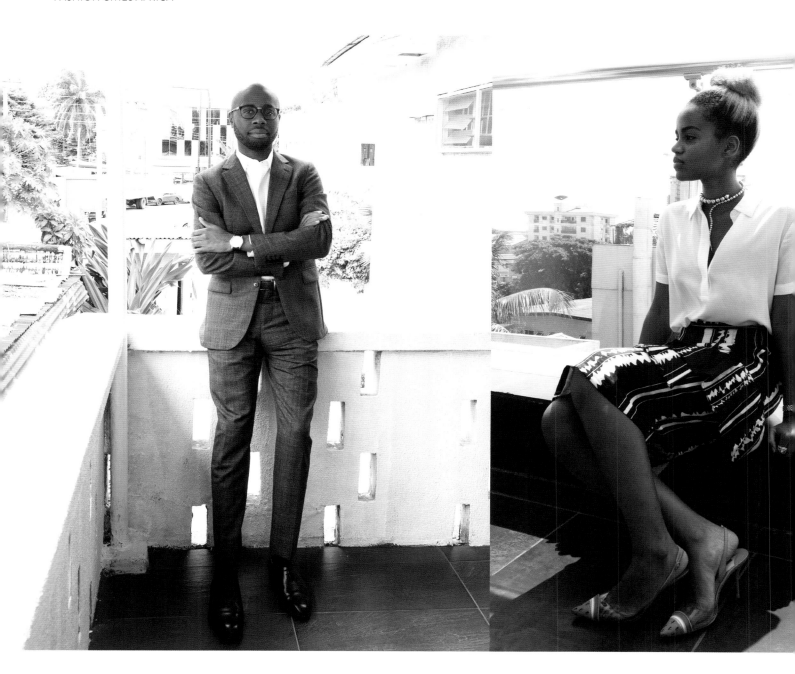

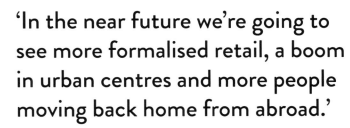

'In the near future we're going to see more formalised retail, a boom in urban centres and more people moving back home from abroad.'

SELINA SUTHERLAND, REPUBLIC OF FOREIGNER

Adeoye Omotayo, PR / author | Selina Sutherland

'Nigeria's fashion has the potential to become one of the country's greatest exports,' says established stylist Bolaji Animashaun who launched *thestylehq.com* in 2014 with its focus on pan-African fashion. Temple Muse was the first world-class lifestyle store to open in Lagos in 2008, stocking high-end Nigerian and international fashion brands alongside a champagne bar. Multi-brand stores such as Polo Avenue, Grey Velvet and Stranger cater to an elite clientele, as does Reni Folawiyo's luxury concept store Alára, which opened in 2015. 'There are so many Nigerian consumers who travel to shop in London, Paris, New York or Dubai. We're changing that mind-set by offering them a unique retail experience at home,' says Avinash Wadhwani, who co-owns Temple Muse with his brother Kabir.

The family entered the once-thriving local textile industry in the 1970s, but by the 2000s their mills, along with a swathe of others, were forced to close due to political and economic uncertainty and cheap imports. This situation prevails, leaving designers to either develop fabrics overseas or to work directly with artisans to make traditional textiles such as *adire* and loom-spun *ase-oke* (a hand-woven cloth), but only in small amounts. It's a loss for a country with such a meaningful connection to the textile trade. Many other challenges still face Nigerian fashion. Weak infrastructure includes poor transportation and an inconsistent power supply. There is a lack of trained tailors and seamstresses and no big manufacturing factories. Futhermore, issues with shipping duties and bureaucratic red tape are just the tip of the iceberg in terms of the lack of support or funding from central government. As a result, designers struggle to produce a consistent product to high standards, competitive price points or seasonal schedules. Often, only those designers well-off enough to weather these storms can afford to be in fashion in Lagos. And while many of them are famed at home and abroad, their businesses are still small in real terms.

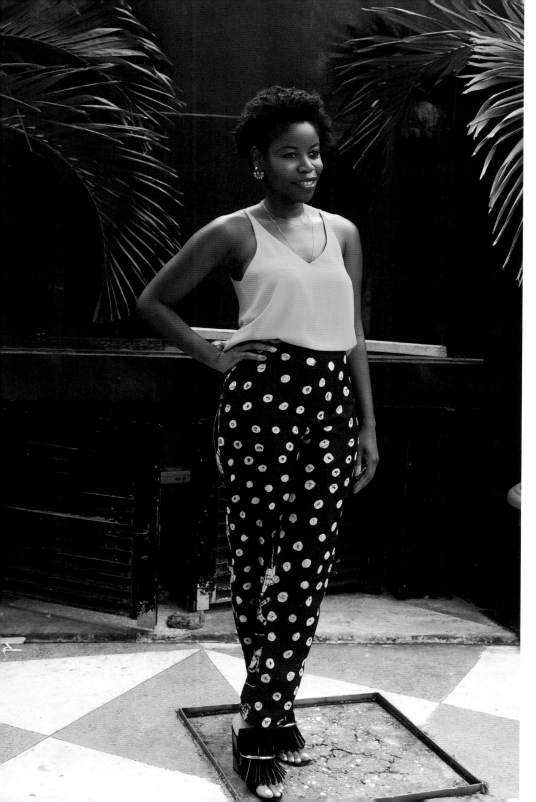

'Nigerians are brand savvy and discerning.'

Ann Ogunsulire

Tokyo James, designer / editor, Made magazine

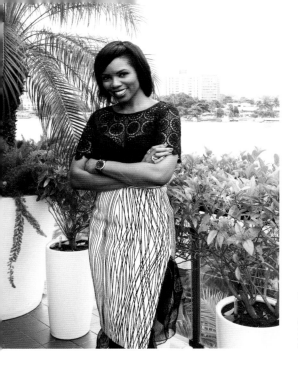

Tokini Peterside

'Lagos now has respected brands but they largely remain one-woman shops. For the industry to grow beyond that, they need significant investment and to fully embrace e-commerce.'

TOKINI PETERSIDE, STRATEGY CONSULTANT / FOUNDER, TOKINI PETERSIDE COLLECTIVE

But success stories like Ejiro Amos Tafiri's are proof that fashion can mean real business. 'People think you can't make money from fashion but you can if you go at it as a business and cater to your customers' needs. It's not a fancy hobby,' says Amos Tafiri, who launched her own store in 2014. She and many other designers have shown at Lagos Fashion & Design Week (LFDW); founded by style consultant Omoyemi Akerele in 2011, it has become a driving force in the Nigerian fashion industry. 'Each year we see signs of evolution and a ripple effect across the scene,' says Akerele, who has also taken designers to international showcases such as *Vogue* Talents, London Fashion Week, and hosted a pop-up at Selfridges. Alongside catwalk shows, LFDW runs business workshops and new designer initiatives.

For today's generation, it's about bringing all of Lagos's creative industries together to form a united voice. There is strength in numbers and that's one thing this city certainly does not lack. 'In African society, it used to be that you were a doctor, lawyer, engineer – or a failure. Now, parents are starting to open up to the idea of creative culture, which is what drives true change and paints the picture of who we are,' says marketing executive Lanre Masha, who works across music, interiors, architecture and fashion. 'What we need is shared knowledge. My generation must take the best that we've learned out in the world and fuse it with our core African values to build a great future. It starts with us.'

Adebayo Oke-Lawal, designer, Orange Culture

LAGOS PROFILES

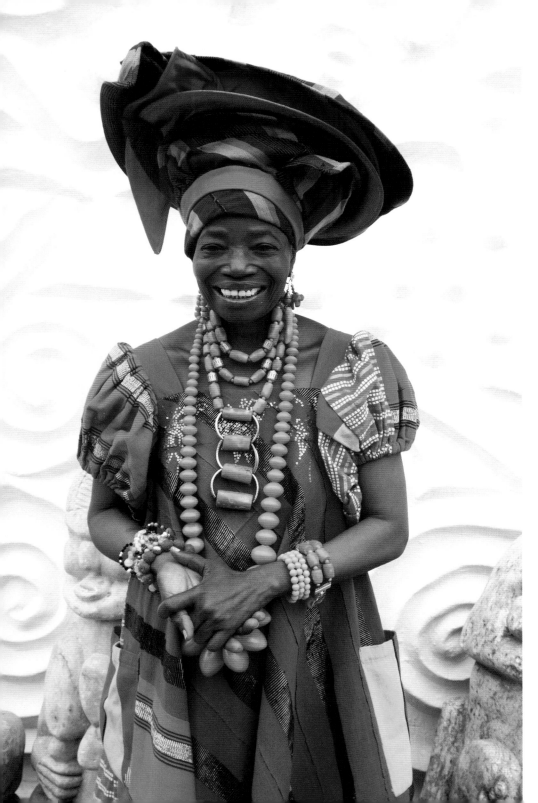

—

NIKE DAVIES OKUNDAYE, NIKE ART CENTRES

This legendary textile designer, artist and women's rights advocate owns the biggest gallery in West Africa in Lagos, plus four further art centres across the country teaching artisanal skills including dyeing, weaving, embroidery and beadwork. She has exhibited globally and inspires a new generation of Nigerian designers.

'When an Ibo woman puts on *oleku* (short blouse and skirt) with a big head tie, she is saying "I'm an independent woman".'

I was born in Ogidi and my mother died when I was six years old. My great-grandmother was the head of the craftswomen in the village and taught me the women's loom and *adire*. When I was thirteen, my father tried to marry me to a minister for the dowry so I ran away and joined a travelling theatre. I discovered how to make wax fabric and patchwork. Designs would come to me in my dreams and my textiles became popular. I was invited to lecture abroad. Now, I teach women skills that will earn them money to feed and educate themselves. They can make a living through textiles.

People wear our fabrics to communicate to society. There are over 400 *adire* designs and each one has a meaning. Indigo is also the colour of love. When you are in love with a man, you wear the design of the gecko. No matter how small his house is, he will find room for the gecko. In the same way, he will find room in his heart for you.

The youth of today are bringing good luck to Nigeria and changing the face of our country. It's great that new designers are going back to their roots to use traditional designs and organic fabrics in a contemporary way. When Amaka Osakwe, the founder of Maki Oh, returned from the United Kingdom, she came to me to learn *adire* and today she is my pride.

Now, we have a fashion industry and in a few years it will be huge. But I'm worried about our fabrics. Factories have closed down. The *ase-oke* loom is dying out. The government has to make new efforts to provide us with high-quality cotton and jobs for the community.

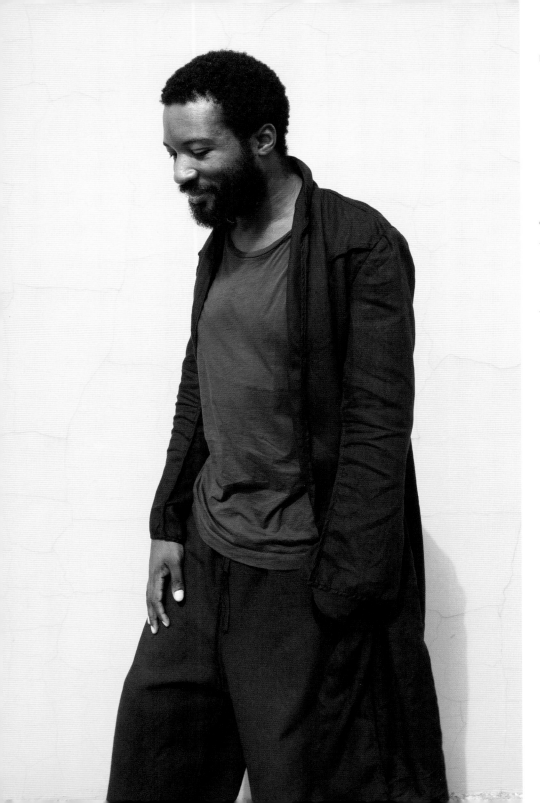

—

YEGWA UKPO, STRANGER

Yegwa Ukpo studied biotechnology in the United Kingdom and worked as a design consultant in Lagos before co-founding the menswear store Stranger with his wife in 2013. It's become a thriving creative salon where designers gather to collaborate and learn.

'Stranger has had a positive influence on new designers who come here to have conversations, read our books and experience the archive.'

Stranger is about moving away from the existing centre. Everything we stock and present comes from this core attitude. It's not about luxury or the avant-garde; it's about creating a calming space that encourages others to discover new directions.

We stock experimental Nigerian designers that aren't readily available elsewhere, including I.Am.Isigo, Kenneth Ize, Orange Culture, Un.sung and U.MI-1, plus an archive of Japanese and Belgian brands such as Yohji Yamamoto, Ann Demeulemeester and Comme des Garçons. We also have a cafe and an indigo dyeing pit. Indigo holds such history and mystique for Lagosians, so we are offering dyeing workshops. We're also developing our in-house menswear brand Sunless, using indigo dip-dye techniques to explore subcultures of utilitarian dress.

In the future, we want to introduce weaving workshops as well. It's my goal to prove that it's possible to make something contemporary on our looms, to bring crafts from our past and project them into the future. Let's start on an artisanal level and then scale up. This country needs to import less and make more.

Stranger has had a positive influence on new designers who come here to have conversations, read our books and experience the archive. We hope to be able to offer small bursaries to help designers learn skills, expand their range of influences and tell the stories they want to tell about our heritage. It's time to be proud of 'made in Nigeria', create sustainable jobs, support the economy and be part of the broader narrative.

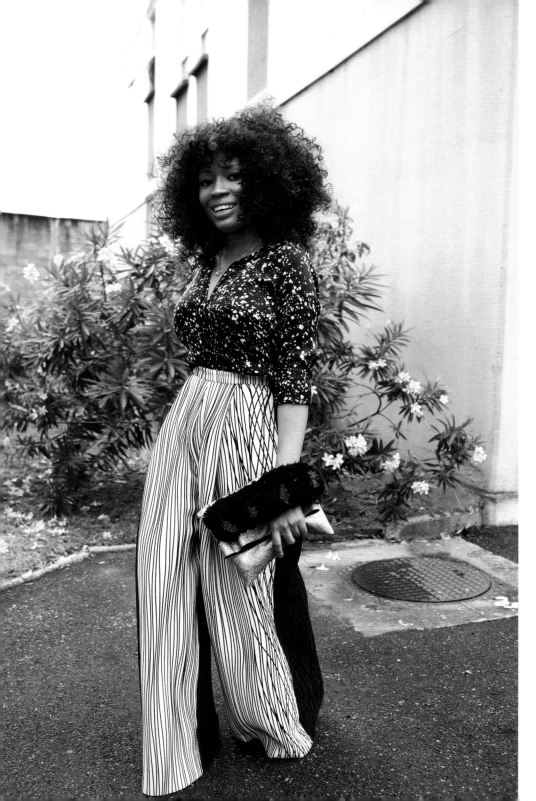

AMAKA OSAKWE, MAKI OH

Amaka Osakwe studied fashion in the United Kingdom before returning to Lagos to launch Maki Oh for A/W'10. Her sensual, intelligent womenswear has won international acclaim, a celebrity following and an invite to the White House.

'Silhouettes, prints and embellishments are packed with hidden meanings.'

There have been many highlights of the brand so far. Having a piece worn by Michelle Obama; winning the Designer of the Year Award at *Arise* magazine Fashion Week 2012; being a finalist for the 2014 LVMH Prize; and showing on schedule at NYFW. A lot of what we've done has been a first for any Africa-based designer, so it feels great to be paving a new trail for the industry and for Africa. It's daunting too, because I don't have a blueprint to follow, I am creating my own blueprint.

I use true African textiles, including *adire*, *ase-oke*, *akwa ocha* and *oja* to illustrate to the world – and Africans – that we have desirable, couture-quality local textiles. *Ankara* (Dutch wax) does not have its origins in Africa yet is perceived to be African. I took this

as my starting point for A/W'15, along with other concepts that have been imported to West Africa, such as the idea of the African mermaid, Mami Wata. Silhouettes, prints and embellishments are packed with hidden meanings. An *adire* print omi (water) covers a dress with a fish-like fin, and another dress is flanked by *ekpaku ubok* (an Ibibio arm band used during fertility dances).

Lagos inspires my work because I live within a culture that I love. It's great to see this spree of development in the industry here. It's an important step in being seen as a strong contender in the international fashion industry. But, in order for it to be sustainable we need a skilled workforce, we need to re-open our textile factories, and we need access to manufacturing and funding.

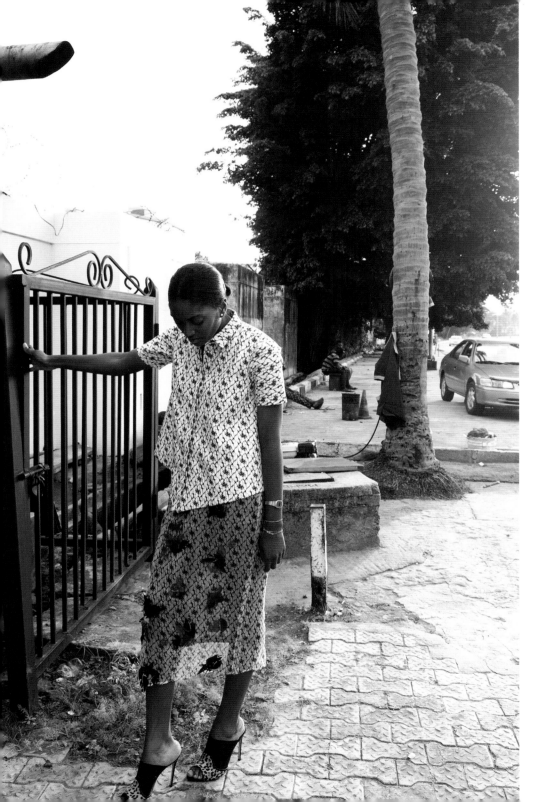

ZARA OKPARA, PR CONSULTANT

Zara Okpara is a public relations consultant (PR) and brand manager who has been integral to building the local fashion landscape. She represents Nigerian designers, namely Jewel by Lisa and Sunny Rose, and international brands coming into the market such as Inglot. She's also on the teams for Lagos Fashion & Design Week (LFDW) and e-commerce platform Oxosi.

'Lagos is seen as the new frontier for African fashion and has evolved very quickly but there's so much more that needs to be done.'

I studied communication in Paris and fashion in London, during which time I became interested in developing companies within the luxury space in Africa. I returned home to Lagos in 2008, where I met Lisa Folawiyo (founder of Jewel by Lisa) on a *True Love* magazine fashion shoot. We discussed my ideas for what I could do for her brand and that's how I started working in the fashion industry.

Back then, very few local designers had PRs. It's been a long journey and we've seen Jewel by Lisa evolve from embellished *ankara* to bespoke prints and the launch of four different lines within the group. She's had pieces exhibited at the Fashion Institute of Technology New York, coverage in US *Vogue*, has shown at NYFW, and has been sold on Moda Operandi. Now her brand is helping to define what Lagos fashion is.

She takes inspiration from her culture to create an aesthetic that women can relate to regardless of where they are from. That's what makes it special.

Public relations isn't as tangible here as it is internationally. People don't go and buy a dress because they see a local celebrity wear it in a magazine. On the contrary, they won't buy it because they want to wear something unique. And we don't have enough of the right kind of media outlets presenting our brands in a beautiful way. It'll take time.

In Nigeria, luxury means hand craftsmanship, making one-of-a-kind pieces that are still accessible. We're creating a new luxury. For me, Chanel is no more special than Jewel by Lisa. It's about a change of mind-set. Within the next five years, luxury will become a significant contributor to the country's gross domestic product.

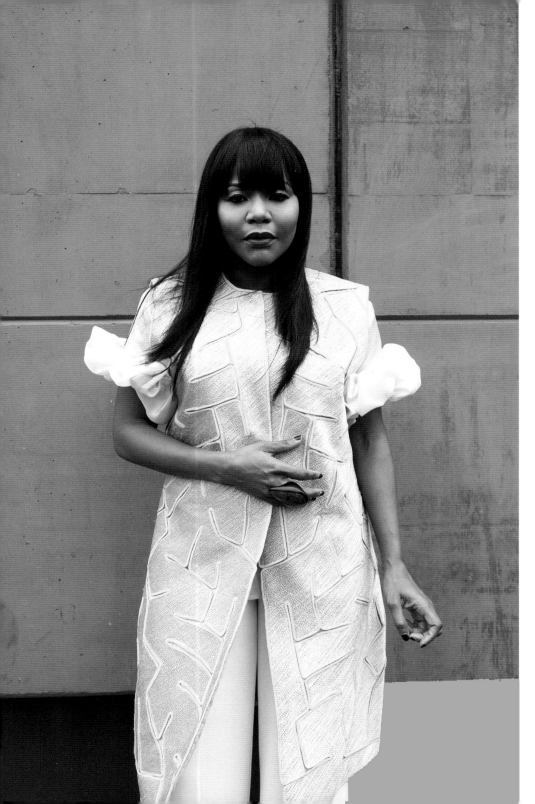

—

RENI FOLAWIYO, ALÁRA

A lawyer and furniture designer, Reni Folawiyo raised the retail bar in 2015 by opening Lagos's first luxury concept store. Alára (meaning 'Wondrous Performer') was designed by renowned architect David Adjaye and houses an expertly curated edit of African and international fashion, art, design and craft, plus a cafe and gardens.

'I hope Alára inspires young Nigerian designers to be the best that they can be.'

My ambition was to build an iconic brand that would become synonymous with contemporary African craftsmanship and design. I want Alára to turn the tide of negative discourse around Africa, and begin to communicate a new story to a pan-African and global audience that redefines the beauty and possibilities of African luxury.

The exterior of the building reflects its surroundings; the red of the earth in the colour of the tiles, the metal fretwork flanking the three-storey structure echoes Yoruba textiles. And once inside, a series of pyramid-like landings encourage visitors to go on their own journey of discovery through multiple levels and galleries to a rooftop space.

Nigerians are expressive in the way that they dress. We love colour, print and beading, which Alára mirrors in the brands we choose, from Duro Olowu and Maki Oh to Stella McCartney and Marni. Ivorian designers Loza Maléombho and LaurenceAirline are best sellers, as are Dries Van Noten and Valentino. I hope Alára inspires young Nigerian designers to be the best that they can be by educating them about what our customer wants. Zashadu has designed a special line of totes for Alára and I encourage Ré Bahia's *kohbaslot* embroidery techniques from Sierra Leone.

People come to shop for fashion but end up falling in love with so much more – a wooden stool from Botswana's Mabeo or a recycled metal sideboard by Burkina Faso's Hamad Outarra. I also commission special pieces from artists, in keeping with Alára's aesthetic, that elevate our perception of regional craftsmanship and heritage. This is just the beginning. Alára is changing how the world sees us.

Mikuathanda Bongela ('Miss Milli B', fashion blogger

JOHANNESBURG

Hannah Azieb Pool

Fashion blogger Milisuthando Bongela is unpicking the politics of Maboneng and Braamfontein – the two areas of town that are current favourites with Johannesburg hipsters. On Saturday it's artisanal bread, raw chocolate and mojitos in jam jars at the Neighbourgoods Market, Braamfontein; on Sunday, it's vintage clothing with an Afro-centric twist at Market on Main in Maboneng. During the week both areas are home to creative studios, workshops and startups. Think the Meatpacking District (New York), meets Shoreditch (London), with a side order of Kreuzberg (Berlin). But there are two crucial differences: in Maboneng and Braamfontein, the hipsters are predominantly (but certainly not exclusively) black, and while some are undoubtedly playing at being style revolutionaries, others are acutely aware of what it means for them to occupy such spaces.

There's always been a relationship between race, politics and fashion and nowhere is this truer than in Joburg, says Bongela, who blogs under the name Miss Milli B. 'It existed in Soweto, it existed in Alexandra, because of the relationship between oppression, fashion, black people and aesthetics,' says Bongela. There aren't many cities with the political and style pedigree of Joburg, and this juxtaposition of fashion, politics and identity is as relevant today as it was 30 years ago.

'My style is feminine, fun and very afrocentric. We have many talented designers in Joburg from all over the continent, I love buying from them.'

SIMAMKELE DLAKAVU, STORY-TELLER / SOCIAL ACTIVIST

'Joburg was the cauldron of the struggle, this is where most of the action went down, this was the home of the black consciousness,' says Bongela. As a result, in Joburg everything is political, consciously or otherwise: the labels you wear, the malls you shop in, the way you wear your hair, it all matters.

'That's the politics of living in South Africa, you can't do anything without considering – who owns this? Who's making the money? Whose culture, whose aesthetic is being propelled?'

More established than Nairobi, not quite as self-conscious as Lagos, the Joburg fashion scene reflects the city's diversity and urgency. 'When I think of our aesthetic, there is an edge, a tension, which makes it exciting,' says Nkensani Nkosi, founder of lifestyle label Stoned Cherrie. Apartheid may be over, but the mood of the city is still sometimes one about to simmer over: 'It's sad but it's also great for creativity. There's something that is alluring, creatively speaking, about it. It's hot here – as in it's boiling – there's always something going on,' says Nkosi.

Johannesburg or 'eGoli' – 'place of gold' in Zulu – has a gold-rush, frontier feel to it. The Joburg fashion scene exists within a sociopolitical context that is unique to the city and its history. Everything is up for grabs and rules are broken easily. 'It's the New York of Africa – you come to find your dreams. There's a certain level of ambition which is your entry-ticket to the city, which shows in how people dress,' says blogger Bongela.

This Joburg vibe is not just about what people are wearing, but the way they are styled, says journalist, PR consultant and designer Maria McCloy. The clothes are the same as people have all around the world, it's how they put them together: 'They'll go to (low-cost store) Mr Price, and mix it with vintage stuff they found from piles of clothing downtown by the taxi ranks. They'll have African influences from their history – beads, braids, etc., it's all in there,' says McCloy whose Afro-centric lifestyle brand Maria McCloy, has been featured in *Marie Claire*, *Elle Decor* and *Cosmopolitan*.

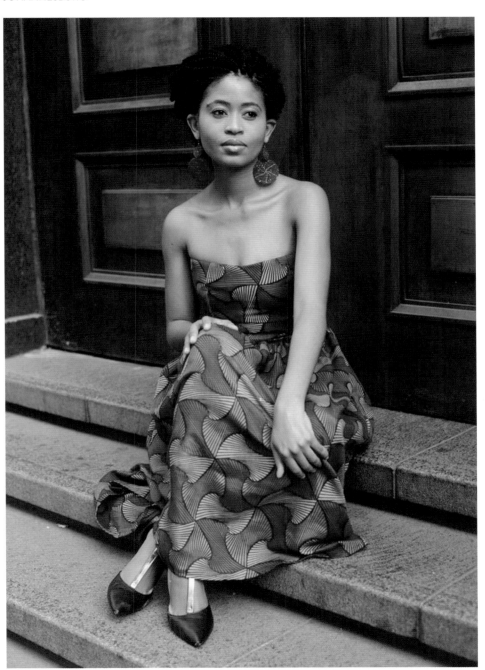

Simamkele Dlakavu

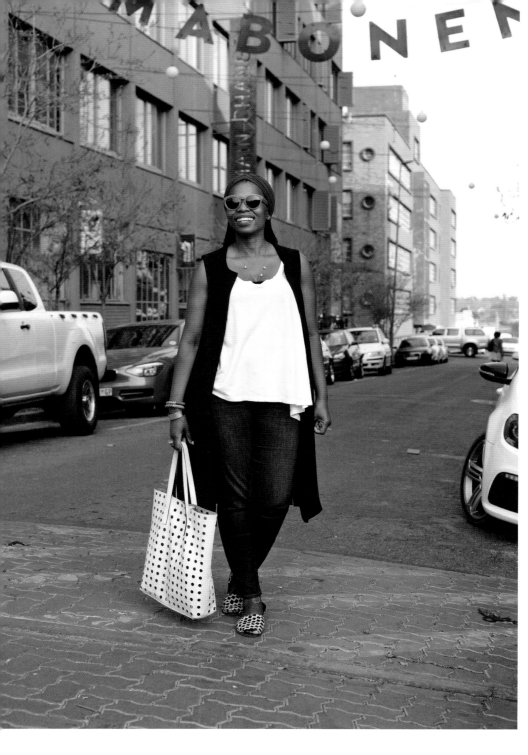

'My style is super funky, stolen from my mom and aunties, super African, and non-conforming.'

YOLANDA SANGWENI, FOUNDER, AFRIPOP!

Yolanda Sangweni

Nkensani Nkosi, founder, Stoned Cherrie

At first glance, it might look like a Joburg hip-hop or skater kid is heavily referencing American culture, but take a closer look and you'll see he's wearing a bucket hat rather than a baseball cap in a nod to Soweto street-style, or the goth girl pouting in the black lipstick has broken up the head-to-toe black with a Zulu-inspired headpiece.

There are different cliques, and even though they have their equivalents across the globe, the Joburg attitude shines through: 'There's "Weavealicious" girl with the bandeaux dress and the Kim Kardashian look; the "Soul Sistas"; the Dandys, with their tweed and vintage; and the hipsters. But with all of them, something about the way they are doing it, there's a Joburg spin,' says McCloy.

Lucilla Booyzen, founder and director of South African Fashion Week (SAFW), agrees: 'You have your Soweto crowd, that is completely different to the set that you get in Hyde Park, or the set you get in East Rand. Then guys like (fashion collective) the Smarteez have a huge following.'

'Joburg is a vibrant city,' says Booyzen, 'there's a love of glamour, but also a willingness to experiment, to mix things up, a boldness that shines whether people are wearing high street or Hermès.'

There are two rival fashion weeks. Booyzen's SAFW, and Mercedes-Benz Fashion Week Joburg, run by African Fashion Week International, founded by Dr Precious Moloi-Motsepe. Both give designers a great platform to show their work and have played a key role in highlighting the energy of the scene.

'I was born in Soweto, with freckles and ginger red hair. This made me different. Joburg is my city, my city is painted on my face.'

FELIPE MAZIBUKO, WRITER / STYLIST

'The city is full of attitude, and much dressier than its laid-back cousins Cape Town and Durban,' says designer Christiaan Gabriël Du Toit, one half of luxury womenswear label KLûK CGDT. 'We have a joke that in Cape Town people keep their Jimmy Choos for a special occasion, in Johannesburg they wear them every day.'

'It's a lifestyle thing, like the difference between New York and Los Angeles,' continues Gabriël Du Toit, who, with his partner Malcolm Kluk, is affectionately known as the Dolce & Gabbana of South Africa. 'We'll dress the windows in Joburg a little bit more bling, add more colour, make them more vibrant. Cape Town is more conservative.' Does their clientele differ between the two cities? 'It's definitely more black in Johannesburg, and that's what we love. There's the excitement, this 'no-fear' aspect, people will try new looks, new styles.'

'Joburg is the only city in South Africa that's really glamorous,' says designer Thula Sindi. 'It's very cosmopolitan. There's a formality to everything and there's a show-offiness to the way people dress which I enjoy.'

Situated in Rosebank, Sindi's boutique, with its low lighting and marble floor, wouldn't feel out of place on London's Bond Street or New York's Fifth Avenue.

Felipe Mazibuko

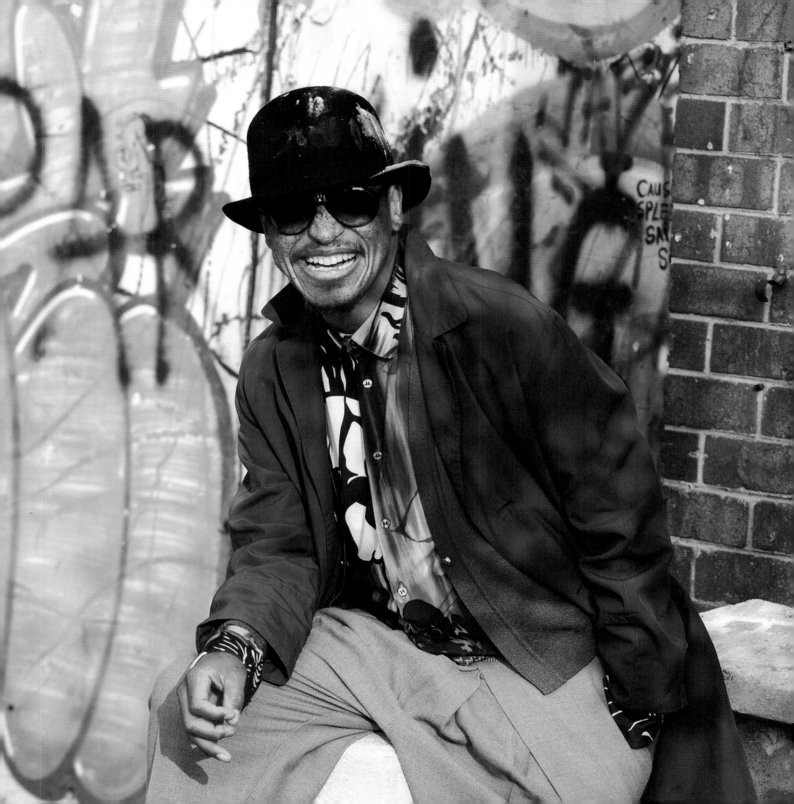

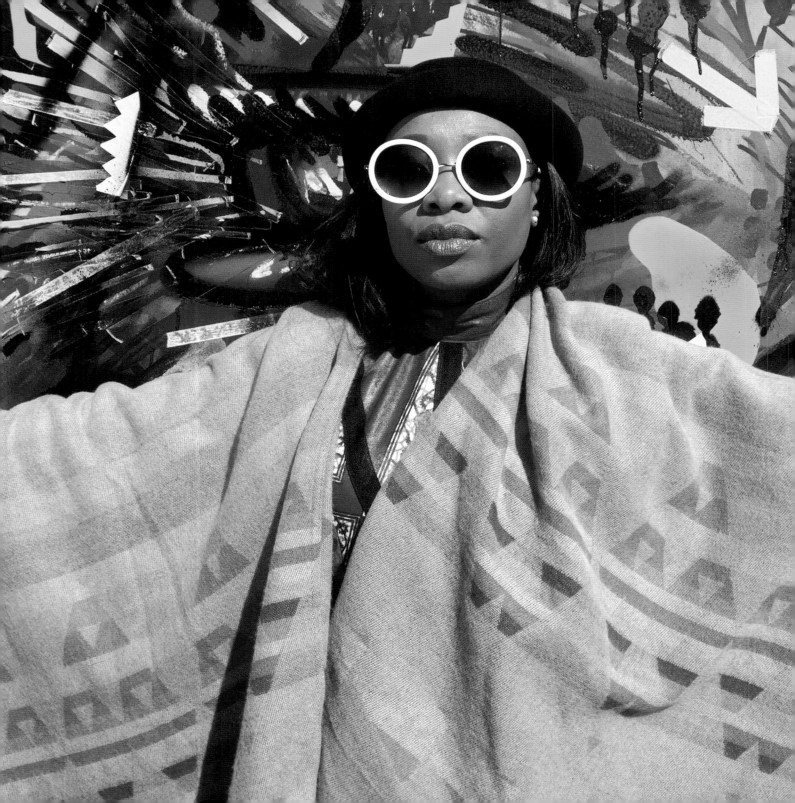

'Every part of Joburg has its own vibe and style. From Soweto to Alexandra, Sandton to Diepsloot and Yeoville to Maboneng.'

MMABATHO SELEMELA, PR / CO-FOUNDER, DESIGNS BY MUSIC

Mmabatho Selemela

'I am kind of Ijaz's stylist, like my brother and father were my stylists – he's open to trying new ideas and looks I suggest.'

PERCY MOSEDIE, CHEF / RESTAURANTEUR

His dresses are hand-stitched, cut beautifully, and make grown women gasp when they try them on. 'I'm trying to create future classics, clothes that you collect like books in a library,' says Sindi. He offers a bespoke finishing service to every customer – a couture experience at a mid-market price range. 'I've got two kinds of customers: people that can afford Christian Lacroix and people who save up to buy what I do.' Even here, politics are never far away: 'Everything is political. Even our mere existence is political. We want to see ourselves in what we wear and what we eat, how we spend our money.'

Across town in Saxonwold, one of Joburg's oldest and leafiest suburbs, sits Leopard Frock, headquarters to designer Marianne Fassler's long-time label of the same name. Fassler's Afro-boho chic has been a staple of the South African fashion scene for 40 years. Her most recent collection is inspired by Joburg: 'If you look at old pictures of the city, or old issues of *DRUM* magazine, there was always an inherent style here.' Leopard Frock reached real prominence in 1976, the year of the Soweto uprisings. During the trade and cultural boycotts of South Africa, when decent cloth was hard to come by, Fassler used vintage African fabrics. As a result, she has a huge archive that she raids for her new collections. 'I'm still here and I still make political statements.'

With flaming red dreadlocks and a stunning collection of local art, Fassler embraces her African heritage in both her work and life; her family have been here hundreds of years, she says. Leopard Frock is deliberately, unashamedly African.

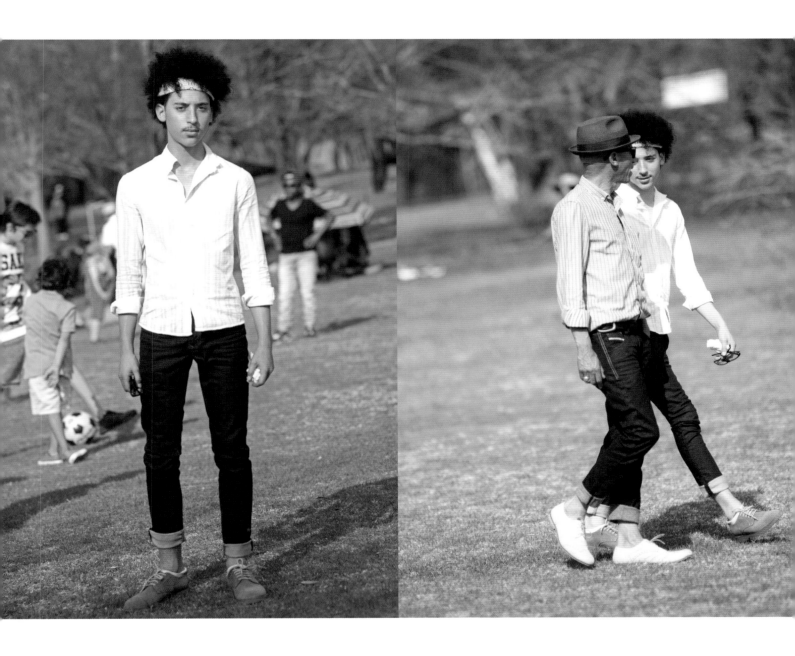

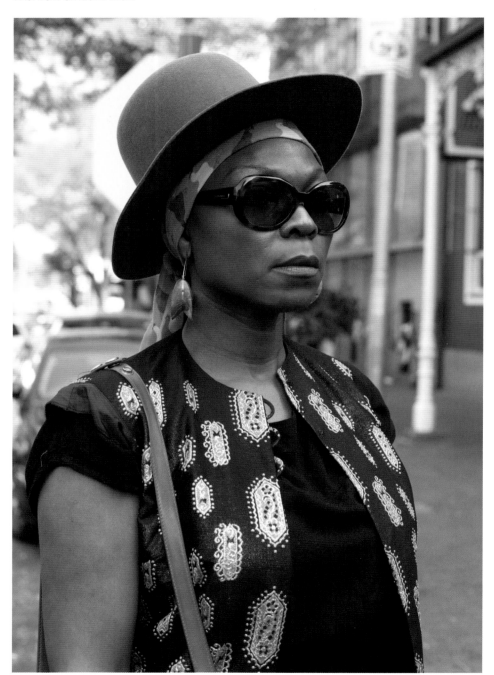

Sthandiwe Kgoroge

'My style is a reflection of my life experiences and travels. A traditional Zulu influence and a vintage western tapestry. I'm an African Global Citizen.'

STHANDIWE KGOROGE, ACTOR / CREATIVE / ACTIVIST

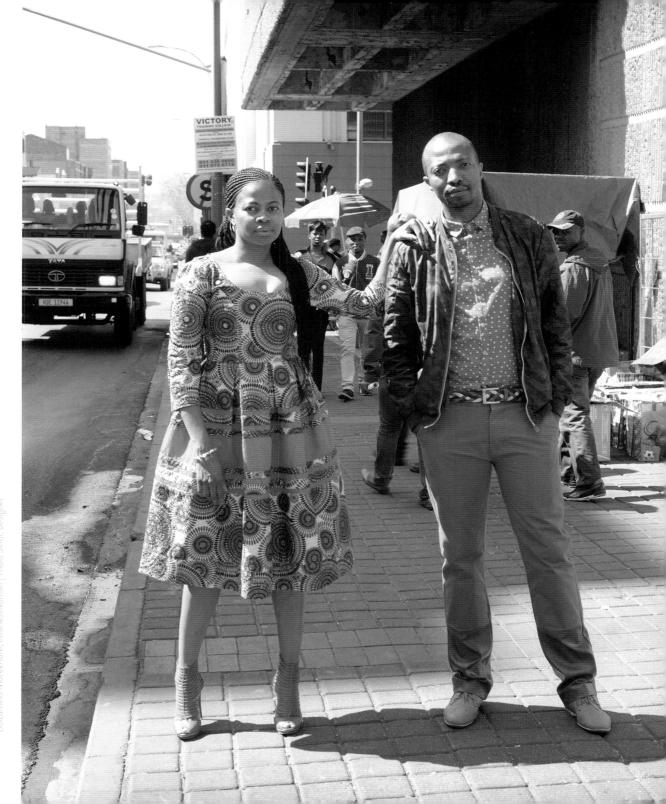

Boitumelo Morekhure, businesswoman | Thula Sindi, designer

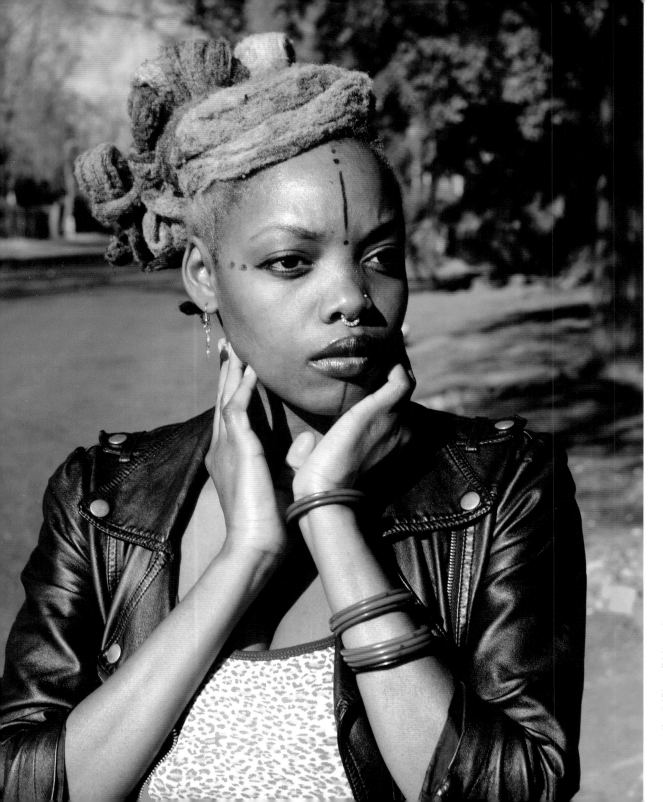

'My style is a combination of vintage, 1950s/60s jazz salons in Harlem and Sophiatown and the liberating madness of the punk-rock aesthetic. Afro-dandy meets AfroPunkz Downtown.'

BONGANI MADONDO, WRITER / CURATOR

By referencing the continent so strongly, she is merely claiming her inspirational source, says Fassler. She has a healthy cynicism for the notion of Africa being 'on trend': 'The trend has been going on a little bit longer this time, but really Africa is absolutely timeless. We've reclaimed or redeveloped a pride in who we are.'

Homegrown designers like David Tlale, who has shown at Paris Couture Week and NYFW, are being increasingly feted by the international fashion set, helping to establish the city's reputation as a style portal.

Meanwhile, fashion and creative collectives like the Smarteez; I See a Different You; the Sartists; and the Ribane siblings, are highlighting and referencing Joburg style in new and exciting ways. The first major project the Sartists did was for a Brooklyn-based label, but rather than try to imitate New York street-style, the collective shot in Alexandra township: 'We could have shot it anywhere, but we decided to use space we are familiar with, and we feel the world doesn't know about; we are trying to challenge the status quo,' says photographer Andile Buka of the Sartists, who have worked with Adidas, Levi's and Converse. 'We have a fashion sense, and we are trying to tell our stories as best as we can through photography, design, writing, and the way we present ourselves,' says Buka. The notion of telling stories through fashion is nothing new, but when it comes to African fashion, both on the continent and in the diaspora, what's changing is the storyteller, and nowhere is the relevance of this reflected more strongly than in Joburg – the city of gold.

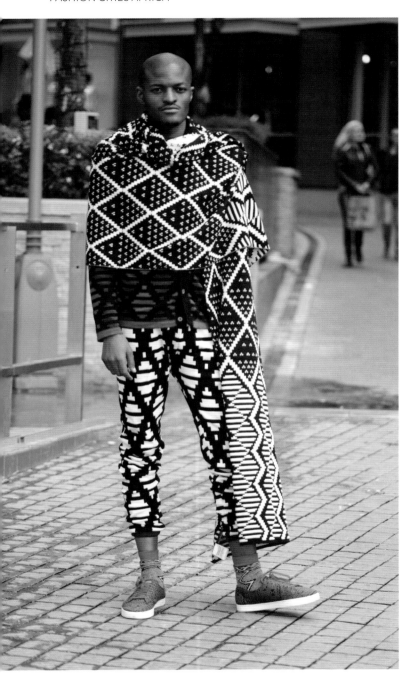

Laduma Ngxokolo, founder knitwear label MaXhosa by Laduma

'At my core I'm a hippie. I love turbans, large rings, bold lipstick colours and I truly believe there's no such thing as wearing or having too many accessories.'

LERATO TSHABALALA, WRITER / EDITOR

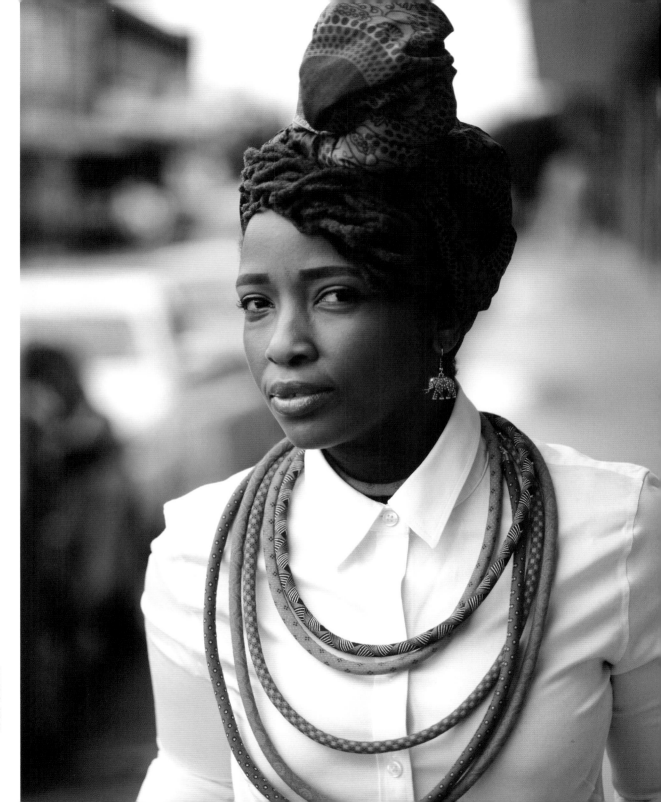

Lerato Tshabalala

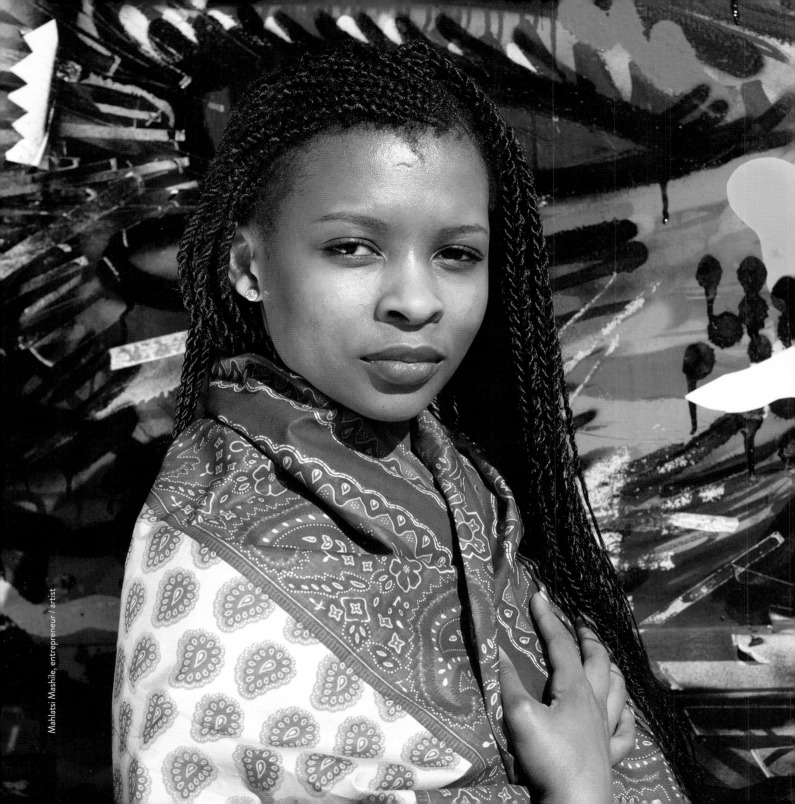
Mahlatsi Mashile, entrepreneur / artist

JOBURG PROFILES

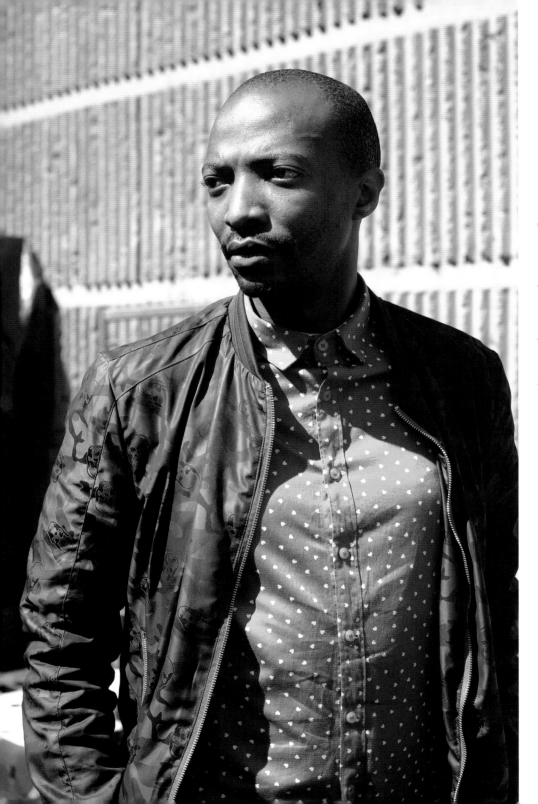

THULA SINDI

Thula Sindi is one of South Africa's leading designers. Sindi has shown at Couture Fashion Week, Paris, New York, Hong Kong, and was named as one of Forbes' '30 under 30': Africa's Best Entrepreneurs.

'I'm trying to create clothes that you collect like books in a library.'

I'm from Klerksdorp, a small town in South Africa's North West Province – it's 'Klerks Town' in English, about two hours from Joburg. I moved to art school in Joburg because I wanted to do fine art; I love painting, sculpture and photography, but fashion seemed like the most dynamic industry to go into because you could combine all of those things: colour, proportion, in an industry that is also immediately commercial – I love selling stuff. I don't think I'm a designer, I'm more like a product developer.

My parents are into the creative arts and music so it wasn't difficult to say, 'I want to do fashion'. The day after I graduated, I started to work for (luxury wax fabric specialist) Vlisco. I did that for a year and a half and then I thought, 'I can do this for myself', so I started my own business. My aesthetic is about design – I love to see a fabric and create

a beautiful product. I'm interested in something that's contemporary, that has a global appeal, with the African touch, but that's not a cliché. I've done a whole collection of African print onto embroidered cotton, just to change textures, to change finishes. I focus on really high quality and an aesthetic that is appealing. I want people to buy clothes on merit. We've got two pattern makers and ten seamstresses. We make the garment from start to finish, it's not like in a factory where you do the sleeve and somebody else does the collar. That's soul-destroying work and it disconnects you from the garments you're making. We work a little bit slower, but the quality speaks for itself and you learn to make clothes in the best way possible. I'm trying to make future classics, that's my raison d'être. I'm trying to create clothes that you collect like books in a library.

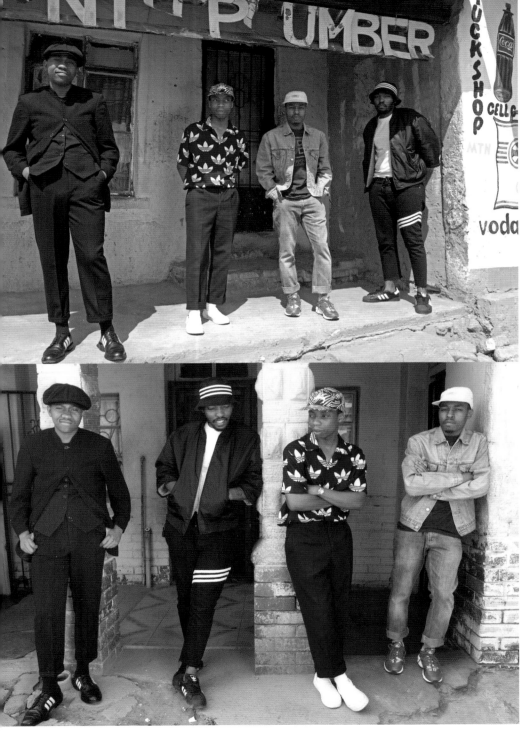

THE SARTISTS

Kabelo Kungwane, Andile Buka, Wanda Lephoto and Xzavier Zulu are the Sartists, a creative collective documenting South African street-style. They have worked with brands including Levi's, Adidas Originals, The Brooklyn Circus, Markhams, Converse, Young and Lazy, and 2bop.

'The reason why we're doing what we're doing, more than anything, is to tell our stories.'

Kabelo Kungwane: I'm from Alexandra township. I got into designing in high school. I was studying history, reading about everything from the French Revolution to Martin Luther King, to Malcolm X to Nelson Mandela. I was intrigued by what they used to wear, their hairstyles, accessories. So from there I used to go out and search for clothes so we could dress like those guys – it was inspiring.

Wanda Lephoto: I am a reflection of my father, the neighbourhood I've grown up in, my mother, my friends, the school I went to, those are the things that have made me fall in love with fashion. I've always tried to blend cultures here with cultures that we pick up over the internet – taking something from my father and my mother and fusing it with something that I see online. Subcultures like punks aren't tangible here, but as a designer I love them because of the history they came with, the liberation they give to people is something I'm interested in.

Andile Buka: I was born in Soweto, but when I was a year old we moved to Orange Farm, the last township south of Joburg before the Vaal Triangle. I'm passionate about this city. There's so much energy. The reason why we're doing what we're doing, more than anything, is to tell our stories. Most people are afraid to do that, they're ashamed of where they come from, or what they do.

Xzavier Zulu: I always used to see things I liked and then I had to make them. I would see a Levi's customised jean and think, 'I have jeans but they're from the corner store', so I'd go and buy bleach and make the things I wanted. I really loved Van Gogh as a child; Rembrandt and all those guys, they meant something to me, they spoke to me from a young age. Chalk, canvas, coal, ink, all those things are mad expensive, but fashion is accessible. Even if it's cheap material, even a T-shirt, I make it in such a way that it forces you past the quality to really look at the design.

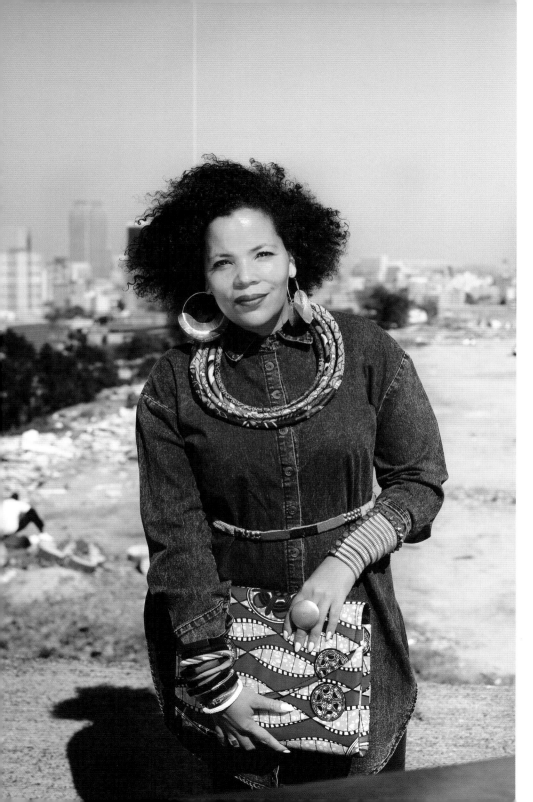

MARIA MCCLOY

Designer, PR consultant and journalist Maria McCloy is founder of accessories and shoe brand Maria McCloy. McCloy is also a founding member of the multi-disciplinary politicised media company Black Rage Productions.

'People see their history in South African and pan-African cloths.'

I've been part of the Joburg urban culture scene since 1998. When people say – 'the designer Maria McCloy' – I'm like, what? But I guess I am, though I didn't study fashion.

My mum's Lesotho, my dad's English; they live in Lesotho, it's home, although I was born in England, lived in Nigeria, Sudan and Mozambique, all before I was five, then Lesotho. I came to Joburg to study – I'm a Joburger – if I could have a Joburg passport, I would.

When I was little, I loved the market. My mum says I used to go on her back, wrapped in a cloth, and I think that paved the way into what I'm doing now.

I started selling earrings in the flea market in Newtown. Then I saw shoes in a bridal shop, found a supplier, started covering them using South African and pan-African cloths, there was something in that that really touched people. I think it resonated because they could see their history, there was a magic in the shoes.

From then it just evolved. I found a factory, started producing women's shoes from scratch. This year I found an amazing factory making men's shoes, so now my men's shoes are better than my women's. When I see the men's shoes I feel like I gave birth. So now I have to work hard on the women's.

I'm working with African style because it's amazing, and because it's beautiful; I've always wanted to work with it, to wear it, it's always inspired me. But I'm also aware of what's been done to us and how people think, so I'm trying to show African style in a new way. Why would anyone not be working with it?

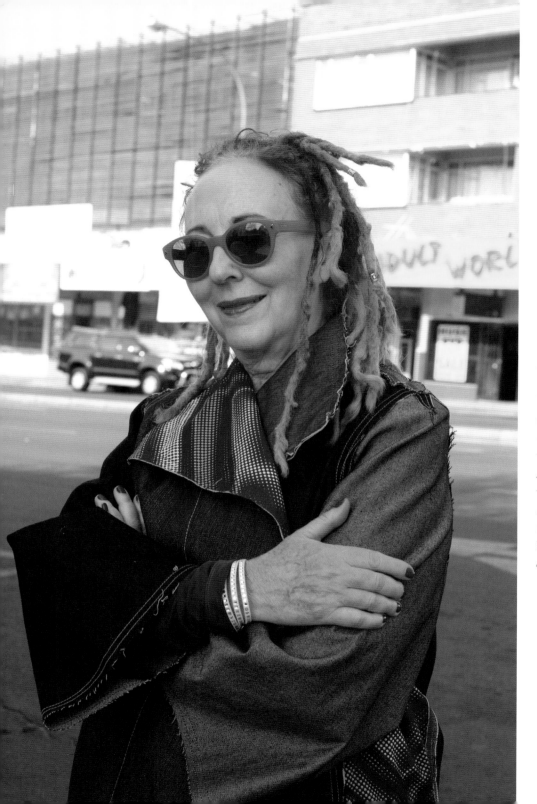

—

MARIANNE FASSLER, LEOPARD FROCK

Marianne Fassler is the founder of established womenswear label Leopard Frock, which has influenced and inspired the South African fashion scene for over 30 years. Fassler has won many awards in her career, including the African Fashion International Award for Outstanding Contribution to Fashion in Africa (2010) and the Mercedes-Benz Fashion Week Africa Designer of the Year (2014). Her work is inspired by the cross-cultural energy of the continent.

'If you want to be unique as a designer
you really need to look outside of fashion.'

**If you ask me where I'm from, I'm
African. My own family have been
here for 400 years. Our work is very
African. We often also have a little
bit of a political handle to our work.
Sometimes very overtly, other times
a little bit more subtly.**

Current affairs influence great
fashion; seminal events affect the way
people behave and dress. So that's how
I respond. Having said that, I don't
believe people want to walk around with
messages and burdens on their backs,
fashion should be frivolous.

I worked through protectionism, the
cultural boycotts, the trade boycotts, all
of that. During those times we created
our own fabrics with scraps, and we
still do; we have a huge collection. We
never throw anything away, which is how
Africa has always worked. Go to Zambia,
you won't find a Styrofoam packet or a
shopping bag floating around in the bush
somewhere, everything gets reworked.
For me, as an ethical brand, it also has to
be made in South Africa.

If you want to be unique as a
designer you really need to look outside
of fashion. We invest our work with a lot.
Because I live who I am, I have very loyal
clients and a very diverse client base.
More and more of them are independent
women, of whatever colour, whatever
descent. What they really find frustrating
is that when they go out shopping there
is nothing they feel like buying, but they
like what we do. My clients are probably
all younger than me, except my mother,
she's 90 and she still buys our stuff.

Joburg is a transient city full of
people looking for something big. For
some it happens, for some it doesn't, and
it's always been like that. It's not an easy
city to live in, you can't ignore it. Joburg
has always been the one that's taken the
endangered, and the flotsam, the ones
who can't find asylum anywhere else;
it's always been that kind of city and as a
result it's got a wonderful cross-cultural,
hip aesthetic to it.

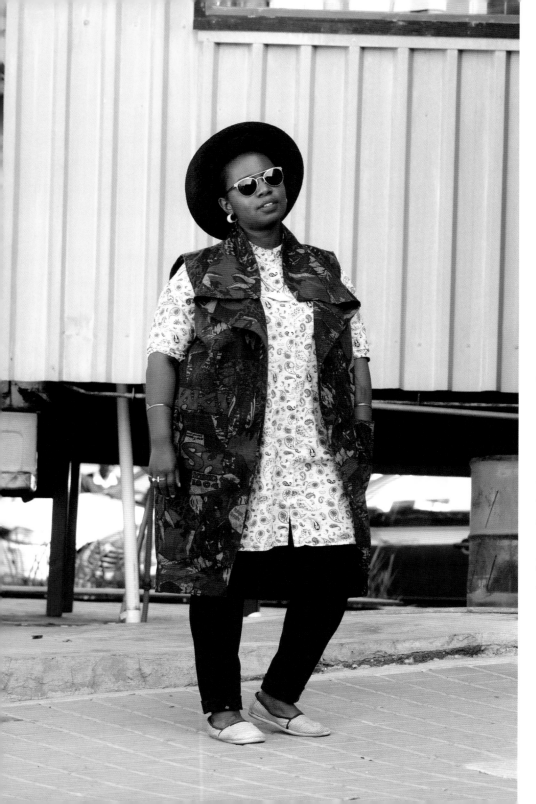

—

ANISA MPUNGWE, LOIN CLOTH & ASHES

Anisa Mpungwe, founder of the womenswear label Loin Cloth & Ashes – 'created to give women an alternative to the little black dress', with a focus on comfort and print. Mpungwe studied at the London College of Fashion and went on to become the first black woman to win the *Elle* New Talent Award (2008). Loin Cloth & Ashes has shown at New York Fashion Week, Mercedes-Benz Fashion Week Cape Town 2013 and Mercedes-Benz Fashion Week Africa 2012.

'I'm telling the story of Joburg through my clothes.'

Loin Cloth & Ashes is quite an experimental label. Initially, the two biggest designers I liked were Alexander McQueen and Hussein Chalayan. My approach to design was quite clinical, I was trying to prove myself as a clever designer. I went head-on with being this 'non-African, but African' designer – it was crazy.

Then a few years ago my mum bought some fabric back from India, I did these skirts that immediately sold out. That's when I started to appreciate who I am, what that means, what my responsibility is to myself, my family, the country where I'm from and within the industry. So then the game changed a little bit. I wanted to reflect the 'urban African'. What they're thinking, what they are influenced by, what they are finding cool; that's what interests,

inspires and influences me. Other areas in the world don't know this kind of Africa. This is how I'm telling the story of Joburg through my clothes. I want to have at least two other stores within South Africa, and I really want to open one in Tanzania, where I'm originally from.

To be an entrepreneur is probably one of the bravest and toughest decisions anyone could ever make. To wake up every day and know that you achieved one more day, or one more year, that's a joy. Joburg has character. Down the road, there's the banking district and you'll see the highest of heels on the cobblestones, you have the mamas across the road making food on the street, next to them is someone who's braiding hair, the culture is so vibrant. It's Africa – we hold nothing back.

Fashion Cities Africa: The Exhibition

Helen Mears, Martin Pel and Harriet Hughes, Royal Pavilion & Museums, Brighton & Hove, UK

The idea for an exhibition about African fashion had been bubbling away for several years among museum staff. An emphasis on the contemporary seemed to offer a way out of the disciplinary and ethnocentric limitations set by our historic collections, which were largely amassed in a colonial context. African material traditionally fell into the museum's ethnography (now, optimistically, 'world art') collection. Unlike objects from certain parts of Asia, few African objects made it into the museum's Fine Art or Decorative Art collections and – at the time of writing – no African textiles can be found in our Fashion & Textiles collection. However, even if it enabled us to escape the limitations set by our historic collections, the exhibition project posed certain challenges, not least who constitutes an 'African' designer: does an African designer have to have been born in an African country or to work in an African country? Must their creations reference traditional 'African' designs or techniques in some way? Must they call themselves a designer, or do other kinds of makers, such as tailors, count? A focus on the city seemed to offer a useful direction. It would enable us to explore a wide diversity of fashion practices, from street-style to tailoring and couture, and get around the difficulty of who is 'in' and who is 'out': anyone working within the fashion industry, in its broadest sense, in that specific city would count.

The city also seemed to offer an exciting, dynamic backdrop to a display about fashion. The African city, like cities the world over, is a place where people from widely diverse backgrounds come together, work together, live together. Different social strata and different ethnic backgrounds are brought into contact. Moreover, over the last half-century many African cities have been transformed by the experience of independence and the political, cultural and economic forces of globalisation, which of course follow centuries of trade between Africa, Asia and Europe. Shopping malls, mobile phones, blogging, the middle-class consumer – these are as much a part of

the experience of the urban African citizen as of the European. Inevitably, these have impacted on the development of African fashion industries. So, too, have the histories of many African cities as ports (Lagos, Casablanca) and railway depots (Nairobi), and they remain places of transnational trade, of arrivals and departures.

A focus on fashion in the contemporary African city solved some problems but created others, most pressingly which cities to focus on. Some have become popular foci of recent exhibitionary practice, not least the megacities of Lagos and Johannesburg, but there were compelling arguments for including other cities: Dakar, Accra, Brazzaville, for example, had much to offer to a discussion about contemporary African fashion. In the end, with a group of specialists we settled on these four, largely for the simple reason that they represented the four compass points of the continent. A display of fashion associated with these four vibrant and widely divergent cities, we thought, would challenge anyone seeking to make easy generalisations about what African fashion 'is' or 'isn't'.

While African dress has been subject to extensive analysis over the years by non-African textile specialists, dress historians and material anthropologists amongst others, African 'fashion' has a more recent history in terms of its appearance in western publications (for example, Rabine 2002, Gott and Loughran 2010, Rovine 2014). The exhibition, it was clear, was riding the wave of a zeitgeist given buoyancy by books such as Helen Jennings's *New African Fashion* (2011) and Jacqueline Shaw's *Fashion Africa* (2014) and others. It follows a growing interest amongst western audiences in contemporary African art and photography. While their advocates point, rightly, to the virtuosity shown by practitioners of these art forms it would perhaps serve us well to question the impulses that direct the beam of western interest onto African artists, makers, designers at this moment as, in retrospect, it might appear to have been an interest driven as much by emerging global markets. A healthy scepticism might be essential to ensuring the interest can be sustained and that any partnerships flowing from it are truly equitable.